The Paths Men Take

© 2016 Contrasto srl
via Nizza, 56
00198 Roma
www.contrastobooks.com

Edited by Alessia Tagliaventi

Translation: Ruth Taylor

For the photographs
© Henry E. Huntington Library;
from p. 126 to p. 145: Courtesy of California State Parks, 2015;
p. 38: © Library of Congress

ISBN: 978-88-6965-639-2

Back cover:
Jack London photographing the skeleton of the *Snark*. San Francisco Bay, 1906

Jack London

The Paths Men Take

Photographs, journals and reportages

Introduction by Davide Sapienza

contrasto

Index

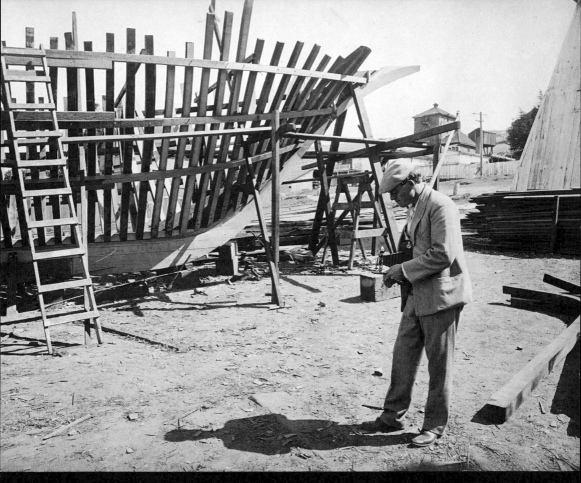
Jack London photographing the skeleton of the Snark. San Francisco Bay, 1906

Jack London, "I would rather live"

Davide Sapienza

> But Buck possessed a quality that made for greatness—imagination.
> *Call of The Wild*, 1903

Jack London, or Adventure

Early on 22 November 1916, Jack "I would rather live" London died at his ranch in Glen Ellen, California. Shortly before his death, he was informed that yet again the dam of his beloved lake, situated among the ranch's sequoia trees, was leaking: "Damn!", he said, thumping his fist. At that moment too, he would rather have lived. But he realized it was over. For now. Much has been said and written about his death, but for over half a century it has been clear that it was not suicide. Nevertheless, the life of John Griffith Chaney, later Jack London, had been a perilous and amazing adventure, in which, at some key moments, dark forces seemed to gain the upper hand. A life that could easily be defined "A great (American) novel", only that it was not fiction but rather imagination in command already at a tender age.

One of his contemporaries, the great psychoanalyst, anthropologist and thinker Carl Gustav Jung, considered forty to be the defining age and, in his way (because Jack only ever did things his way), during those incredible years, London chose more than one life, explored dozens and experienced a great number of others. He came to the world's attention in 1900, with the huge success of his stories devoted to the Great North in the Yukon and the short story collection *The Son of the Wolf* introduced the cultural establishment to a controversial and

unclassifiable figure: an author who did not write for the establishment, but to ensure that his books were read.

Born John Griffith Chaney on 12 January 1876 (the same decade as Jung and Einstein), from an early age he demonstrated a great propensity for the Adventure of Adventures: Life. His story is an impetuous river carving into the spirit of the times and broadening its banks, but at the same time also shaped by it; it is the story of an explorer of men and minds searching for everyday stories to fashion into visions and ideas that were his and his alone. Yes. Jack London was a true storyteller.

In order to communicate his message, he chose writing, but not that alone, and this book sets out to prove it. A work that is organic, and focuses on a particular period, roughly midway through his literary career, which was at its peak between 1900 and 1916. During this time, London, an avid explorer of man's civilization (from scientific and philosophical ideas through to artistic thought; technology and politics, culture and art), took over twelve thousand photographs: something that well reflects the extent of his experiences. He was no amateur, he knew what he was doing and how to do it. He had studied the new art to the extent of defining his images "human documents", as valuable to him as his novels, stories, journalism, and editorials. And in two specific books, the photos included were entirely his own: namely *The People of the Abyss* (1903) and *The Cruise of the Snark* (1911), the fruit of his experiences at the beginning and end of the voyage that this book traces and which reveals just how much of life Jack London had recounted, highlighting the enormous shift that occurred in his own life between 1902 and 1907.

The problem of those who live only half a life (or even less), and simply at a desk, believing that life is contained entirely in shelves full of books, is the subconscious fear of people like Jack London. Too much stuff. Wavelengths that are inacces-

sible to the atrophied body (and hence the mind). Those like Jack are torrents that hurtle over steep precipices, water that offers its precious drops to those who wish to receive it and bath in the spirit of the spring. Jack London did not collect and bottle this water, but rather, he attempted to follow its path wherever it might lead. And this he did, avoiding precipices and obstacles, because after all, Adventure was there to be lived. As simple as that.

The explanation for this zest for life lies in a letter written from the ranch in Glen Ellen in 1910, in response to a reader who found him aged. Jack, you're over the hill, the reader dares to tell him. Who, me? "I am living so damned happily that I don't mind If I do go to pieces. I prefer living to writing." When you tackle Adventure-Life head-on with enthusiasm, voracity, the desire to explore it, you run risks too, also of an artistic nature, because if you truly want to make your contribution to humanity, of course you would rather live than write. London wrote nothing that he had not previously experienced—intensely, passionately, consciously. Even the most esoteric of his stories (I'm thinking of the late masterpieces such as *The Star Rover* and *The Red One*). When the general public allowed itself to be sucked into the epic of the Far North, it was because the narrator that throbbed within him had spent a year in the polar regions, on the edge of the Arctic Circle, ruining his hands, back and skin at temperatures of minus forty degrees celsius, suffering the deprivations that would result in scurvy. When he returned to tell his tale, like a Virgil of the geographical and inner wilderness, he led humanity on incredible adventures of the creative imagination, the totem to which Jack London was to devote his entire life.

The beginning of his ascent is the perfect and symbolic combination of the themes that will be covered in this book: returning to California in 1899, Jack studied all that the science of the time could offer in order to render the stories he had mem-

orized real and, combining it all with his philosophical and scientific interests, transformed "the road" (whether on dry land, the river or the sea) into a typically American concept, already present in other guises, including Thoreau, Twain and Melville. The importance of photography was also very clear to him: it could immortalize "the road" and he learnt its rudiments from Fred Jacobs, an old school friend in Oakland. Before he died, Jacobs had been engaged to Bess Maddern, who was eventually to become Jack's first wife, and it was with her that the young London created a small dark room in which to develop the photos taken on outings during their courtship. On 5 November 1900, he wrote a letter to his friend Cornelius Gepfert, who he had met on the Stewart River during the long months spent in the Klondike and who had then returned north to look for gold: "when on a jaunt down to Dawson, if you should run across any good photographs of the country, dogs, dog-teams, water, ice, snow, hill, cabin, raft, steamboat, ice-run, etc, scenes, buy them and send them out to me, and then I will send in the cost of transportation and purchase price… I haven't any fotos of the country and… I haven't ceased kicking myself yet for not having taken a camera with me."

This book recounts the journey into the immense world of his primigenial and candid gaze, without anything superfluous: fundamental stages in which Jack London became witness to the great events of his time, episodes whose outlines expand and emerge from the human documents on London, the Russo-Japanese War (which, in its extensive use of destructive technology and massacre on a vast scale, was a testing ground for the Great War of 1915-1918), the San Francisco earthquake and the incredible voyage of the *Snark*. Four journeys that recount a period straddling two centuries, all concentrated in the years which for Jack London the writer evolved in four principal directions: the short stories; the narrative masterpieces

(*The Call of the Wild*, *The Sea-Wolf*, *White Fang* and the short novel *Before Adam*); non-fiction (writings later collected in *The Road* and the *Cruise of the Snark*); books of social criticism (such as *The People of the Abyss* and *The Iron Heel*). All fully in keeping with the images included in this book in which London focuses on the details that render the subjects unique. His human documents are timeless snapshots, moments captured in situations bound to a common destiny: the path of humanity.

The Cape Horn of the Abyss

In April 1894, Jack was eighteen years old. He had already been a seafarer, an oyster pirate, and young cabin boy in Japan hunting seals for seven months (a voyage that inspired his first short story, published in 1893 in *The Call* in San Francisco, "Story of a Typhoon off the Coast of Japan"). Unemployed by choice, he heard a speech by Charles T. Kelly, a sociology scholar who was setting up his Industrial Army, one of the contingents of Coxey's Army of the Unemployed. The plan was for every contingent from across the United States to converge on the capital at midday on 1 May 1894. The young London was in search of adventure. Something was burning inside him ("man, who is the most restless of life" as we read on the opening page of *White Fang*). The notion of social justice had yet to crystallize, but the notion that man might obtain his desires by enduring tough ordeals already had. Everything was about to change and, as if sensing this, for the first time Jack took with him a notebook in which to jot down notes, which were to result in the seven reportages subsequently assembled under the title *The Road*.

In those months "on the road", he witnessed everything he was to draw upon in *The People of the Abyss* and in his war correspondence. Because it was this experience that changed

his view of America and the world. Not only is *The People of the Abyss* a very painful book, but it was also the result of a vision formed through the experiences of the previous eight years: this work is the Cape Horn of his publishing career. In 1903, he reiterated this in the autobiographical essay significantly entitled *How I became a Socialist*:

"Just about this time, returning from a seven months' voyage before the mast, and just turned eighteen, I took it into my head to go tramping. On rods and blind baggages I fought my way from the open West, where men bucked big and the job hunted the man, to the congested labor centres of the East, where men were small potatoes and hunted the job for all they were worth. And on this new *blond-beast* adventure I found myself looking upon life from a new and totally different angle. I had dropped down from the proletariat into what sociologists love to call the "submerged tenth," and I was startled to discover the way in which that submerged tenth was recruited.

I found there all sorts of men, many of whom had once been as good as myself and just as *blond-beastly*; sailor-men, soldier-men, labor-men, all wrenched and distorted and twisted out of shape by toil and hardship and accident, and cast adrift by their masters like so many old horses. I battered on the drag and slammed back gates with them, or shivered with them in box cars and city parks, listening the while to life-histories which began under auspices as fair as mine, with digestions and bodies equal to and better than mine, and which ended there before my eyes in the shambles at the bottom of the Social Pit"[1].

1. Jack London, *How I became a Socialist*, included in *War of the Classes*, Macmillan, 1905.

The hoboes of 1894 are like the destitute of 1902, with the addition of men, women, and children who are dying on the streets of a civilized London, capital of the homeland of that same "blond-beast" that had swept away the native Americans, men, women and children we can see in these terrible, almost rarefied images. Jack arrived in London on 6 August and when he returned to New York on 13 November, the ideological metamorphosis that had begun in 1894 on the hobo trail was complete. *The People of the Abyss* is a momentous work unmasking the hypocrisy of the industrial revolution, capitalism and any other form of social soporific in which mass communication is complicit:

"It is quite fair to say that I became a Socialist in a fashion somewhat similar to the way in which the Teutonic pagans became Christians—it was hammered into me. Not only was I not looking for Socialism at the time of my conversion, but I was fighting it. [...] I sang the paean of the strong with all my heart.

This was because I was strong myself. By strong I mean that I had good health and hard muscles, both of which possessions are easily accounted for. I had lived my childhood on California ranches, my boyhood hustling newspapers on the streets of a healthy Western city, and my youth on the ozone-laden waters of San Francisco Bay and the Pacific Ocean. I loved life in the open, and I toiled in the open, at the hardest kinds of work. Learning no trade, but drifting along from job to job, I looked on the world and called it good, every bit of it.

Let me repeat, this optimism was because I was healthy and strong, bothered with neither aches nor weaknesses, [...] And because of all this, exulting in my young life, able to hold my own at work or fight, I was a rampant individualist.

It was very natural. I was a winner. [...] And I looked ahead into long vistas of a hazy and interminable future, into which, [...], I should continue to travel with unfailing health, [...] I could see myself only raging through life without end like one of Nietzsche's *blond beasts*, lustfully roving and conquering by sheer superiority and strength.

As for the unfortunates, the sick, and ailing, and old, and maimed, I must confess I hardly thought of them at all, save that I vaguely felt that they, barring accidents, could be as good as I if they wanted to real hard, and could work just as well. Accidents ? Well, they represented FATE, also spelled out in capitals, and there was no getting around FATE. Napoleon had had an accident at Waterloo, but that did not dampen my desire to be another and later Napoleon. Further, the optimism bred of a stomach which could digest scrap iron and a body which flourished on hardships did not permit me to consider accidents as even remotely related to my glorious personality.

I hope I have made it clear that I was proud to be one of Nature's strong-armed noblemen. The dignity of labor was to me the most impressive thing in the world. [...] Work was everything. It was sanctification and salvation. The pride I took in a hard day's work well done would be inconceivable to you. It is almost inconceivable to me as I look back upon it. I was as faithful a wage slave as ever capitalist exploited. [...] In short, my joyous individualism was dominated by the orthodox bourgeois ethics"[2].

But the transformation was such that in a personal letter written on 16 August to his friend, the intellectual Anna Strunsky, from his room in Dempsey Street, situated in Stepney in

2. *Ivi.*

the heart of London's East End, to which he returned every so often for a few hours to cleanse himself of the horror and to work on his notes and images: "Am settled down and hard at work. The whole thing, all the conditions of life, the immensity of it, everything is overwhelming. I never conceived such a mass of misery in the world before"[3].

At the end of September, he informed his publisher that the book (with the relative photographs) was ready, he left England for France, then travelled to Berlin and, finally, to Italy. It was his well-deserved vacation. Ahead of him lay a year that was to prove decisive for his career, twelve months in which he was to come to the world's attention through his talent and his courage. And his vision.

The Eyes of a Dreamer

Reading the excerpts that accompany the images in this book, it is only natural to link the two most obvious components of a crystal clear talent, thus highlighting the levels of expression Jack London had achieved by the time he was thirty. What is striking is the evocative power of his photos and the vivid search for a realist aesthetic, evidence of the desire not to embellish anything concerning the image, other than a context based on reality. At this time, photography was starting to open up new opportunities and new authors capable of documenting reality were beginning to emerge, providing a glimpse of the medium's enormous potential: the categories that were to become more clearly defined during the course of the twentieth century did not yet exist, but with his Kodak,

3. Letter to Anna Strunsky, dated 16 August 1902, published in Earle Labor, *Jack London. An American Life*, Farrar, Straus and Giroux, New York, p. 164.

London perfectly captured the fields that were to become fundamental in mass communication, namely photojournalism and war reporting. At that time, one of the major exponents of photography in San Francisco was Arnold Genthe (1869-1942), one of London's acquaintances (many portraits of Jack are by him) who had developed the art of capturing urban poverty by concealing a small camera under his coat. In 1906, Genthe became famous for his photos of the San Francisco earthquake. The two men admired each other and Genthe was very struck by London's appearance: "he had a delicate, intense face and the eyes of a dreamer." This is evident in portraits of him, in which the transparency of that visionary gaze is hypnotic. A gaze capable of capturing the complex reality that surrounded him with great naturalness: that instant in which a story is born and then develops through emotional involvement and technical ability in a mental process capable of continuous synapses.

So Jack London was right there, at the dawn of the first true era dominated by the mass media. In 1900, the year in which he achieved his first publishing success, Eastman Kodak's famous Brownie model camera appeared, in postcard format, a revolution that was to popularize photography and, from 1902 onwards, thanks to the Kodak Developing Machine, make it possible for anyone to develop their own pictures. For Jack London, photography was first and foremost a way of gathering "human documents" in far-off lands, considering that the majority of his photos originated in foreign countries. His images, however, differ from those known in the latter half of the nineteenth century, when the war photographers who followed the Western armies intent on colonization depicted dramatic changes highlighting the peculiarities of foreign lands, dwelling on the racial differences.

This kind of testimony, accompanying occupying armies, gave rise to the notion of the photographer as adventurer: the

public was struck by the power of the images disseminated in newspapers and magazines, and began to see photographers as men capable of narrating the differences between their own culture and those of distant populations. But there was still a piece missing in order to achieve modernity. Then along came Jack London, who turned everything upside down, showing the futility of war, and the poverty of peoples but also their dignity. The greatest proof was London, capital of a hypocritical England, home of the industrial revolution and capitalism, now at the zenith of the orgy of colonial power represented by the British Empire. The very same Empire that was incapable of feeding its own people. But from the abyss of the East End emerged that mature gaze, hungry for the truth, the one that Jack London was subsequently to unleash during the Russo-Japanese war. Right in the middle of these two great periods of travelling through foreign lands from West to East, was a miraculous year: in 1903, he published *The Call of the Wild*, *The People of the Abyss*, and the epistolary and philosophical novel *The Kempton-Wace Letters* with Anna Strunsky. In addition, he wrote *The Sea-Wolf*, which would appear the following year.

Before Christmas, he returned home after spending two months aboard the *Spray* with his friend Cloudsley Jones, while in his personal life he continued to navigate stormy waters, being plagued by problems with his wife and financial difficulties, despite his success (for *The Call of the Wild*, he was paid a flat fee, and not author's rights). So when he was invited to go and cover the imminent conflict between Russia and Japan, he grasped the opportunity to set off once again for exotic lands in search of adventure.

In 1894, Japan had declared war on China, which, in its turn, had laid claim to Korea, thus angering Japan, which won the war and invaded Manchuria and Port Arthur on the Liaodong Peninsula, despite France, Germany and Russia opposing an

invasion of the entire peninsula. The Russians, however, had negotiated with the Chinese the possibility of extending the great Trans-Siberian railway across Manchuria itself as far as Port Arthur, creating the perfect background for a conflict of economic and geopolitical interests. As both Russia and Japan wanted absolute control over Korea's economy, when the latter saw its hopes of any recognition in the partition of the coveted region of Asia dashed by the international powers, and following the humiliation of the unilateral breaching of a series of treaties by Russia, this was the final straw. Russia had in fact negotiated directly with China its entry into Manchuria and Korea, where it had established a naval base in Port Arthur. In these circumstances, having offended Japan, war now seemed inevitable.

The mass media sensed that the situation was about to explode, and was convinced of a speedy victory by the Russian Bear: thus a frantic search for famous reporters to follow the crisis ensued. When the celebrated newspaper magnate William Randolph Hearst decided he wanted the best, but Richard Harding Davies was snatched by *Collier's*, he turned to the man of the moment, Jack London. And Hearst's was one of those offers it was impossible to refuse.

The discovery of embedded journalism

On 7 January 1904, after posting the manuscript for *The Sea-Wolf* to his publisher, Jack London boarded the *S.S. Siberia* with other journalists, bound for Honolulu and then Yokohama. The voyage lasted for seventeen days, which turned into a gloomy premonition of the months to come. During the voyage, following a bout of influenza, Jack twisted his ankle and, reflecting on the imminence of war, was well aware of what might lie in store for him: "I knew that, proportionately, the mortality rate for war

correspondents was higher than that for soldiers. I had heard everything about the conditions in places where life is intense and you experience moments that are immortal"[4]. In Tokyo on 24 January, he came across forty or so correspondents waiting to be transferred to the front, following the Japanese. However, the authorities had no intention of allowing journalists close to the front line. But the young man, the very same person who for three months had immersed himself in the misery of London's East End, had no intention of allowing himself to be seduced by Japanese sirens (dinners, shows, parties): and so, once again, he chose Adventure.

First of all, he had to reach Chemulpo. Jack left Tokyo heading for Nagasaki, but the steamer was full; he then booked a passage on 1 February from Moji, and in the meantime went to take photographs: unfortunately Moji was a fortified town and he was unaware that taking photos was forbidden: "Japanese police 'Very sorry,' but they arrested me. Spent the day examining me. Of course, I missed steamer. 'Very sorry.' Carted me down country Monday night to town of Kokura. Examined me again. Committed. Tried Tuesday. Found guilty. Fined five yen and camera confiscated. Have telegraphed American minister at Tokio, who is now trying to recover camera." Some local correspondents and Richard Harding Davis, together with Lloyd Griscom, the United States Minister to Japan, came to this aid, enabling him to get his camera back. The front, however, was still a very long way away.

On 8 February 1904, Admiral Togo's fleet launched an attack on Port Arthur, in the great naval battle that was to last until May. Jack had received no official communication, but he had a good nose for news and having observed a fleet of battleships leave the

4. Earle Labor, *Jack London. An American Life*, chapter 16, p. 189, Farrar, Straus and Giroux, 2012.

Yellow Sea and that soldiers "had been called from their homes to join their regiments in the middle of the night", he let himself be guided by his instincts. He was certainly not "embedded" and, in gung-ho fashion, and at the risk of sinking, he found a sea passage to Mokpo, a hundred kilometers or so from Chemulpo, where the troops were disembarking and heading towards the Yalu River and Manchuria. He paid for a small Korean fishing boat to take him along the peninsula, where the boat almost sank. It was the middle of winter, with snow storms and blizzards at sea. On 13 February, he wrote to Charmian Kittredge, his future wife: "Never thought a sampan (an open crazy boat) could live through what ours did. [...] driving snow squalls"[5]. Following an extremely hazardous voyage, on 16 February he reached Chemulpo, where he met two colleagues who had managed to get there under their own steam before all journalists were detained in Tokyo by the Japanese authorities. They were also waiting to head for the front. Robert Dunn, a photographer for *Collier's*, recalled Jack London thus: "I want to say that Jack London is one of the grittiest men that it has been my good fortune to meet. He is just as heroic as any of the characters in his novels. He doesn't know the meaning of fear... When [he] arrived in Chemulpo [he] was a physical wreck. His ears were frozen; his fingers were frozen; his feet were frozen. He said he didn't mind his condition so long as he got to the front... He had been sent to do newspaper work, and he wanted to do it"[6].

Ah yes, his job. A glance at the precious images taken over those few months suffices to capture the vivid voice of the "human documents." It is clear that Jack's interest covered a wide range of subject matter: we can perceive compassion and human

5. Letter to Charmian Kittredge, 13 February 1904, published in Earle Labor, *op. cit.*, p. 191.

6. *Ibidem*, p. 192.

solidarity, the dignity of the individual, no matter what "uniform" he is wearing. The eye is penetrating, without prejudice, and is not influenced by any preconceived ideas. Jack London witnesses and creates a story that reflects reality. Even when he is photographing soldiers, there is no contrast between military versus civilian: the tragedy belongs to one and all. But it is the road that emerges in all its vitality: the place where life dynamically unfolds, of relocation, of the movement of refugees, soldiers and vehicles. The road of man.

Dismissive of his own health and the restrictions imposed by the authorities, Jack lost no time and prepared to head north towards the Yalu River and Manchuria, where the Japanese army was gathering two hundred thousand men to attack eighty thousand Russian soldiers. With five horses and four men (an interpreter, a cook and two grooms in charge of the horses), by 4 March he had covered over half the distance from Seoul to the Yalu River. Lying to the authorities, he slipped into Poval-Colli, then Ping Yang, and five days later had reached Sunan. By then, Jack could almost smell the front, now only sixty kilometers away. In the meantime, he kept himself busy: over the previous five weeks he had managed to send nine dispatches to *The Examiner*, the first of which was published on 27 February. Then, finally, on 5 March, for the first time he wrote about a battle on dry land, when a small vanguard contingent of Russian Cossacks crossed the Yalu at Wiju in order to ascertain how far the Japanese army had advanced. Then the Japanese sent him to Seoul, where he stayed for a month. It was not until mid-April that fourteen correspondents received permission to head towards the front with General Tamemoto Kuroki: "they showed us what they wanted and the main concern of these officials was to prevent us from seeing anything at all"[7], he reported.

7. Earle Labor, *op. cit.*, chapter 16, p. 196.

On April 24, he was on the banks of the Yalu River awaiting the first great battle. Until then, he had been able to move around quite freely and, once in Korea, had also been able to take many photographs, sending hundreds to *The Examiner*. But in Manchuria, all this changed: there was no question of taking any photographs of military operations. The journalists wrote what the Japanese officers in charge of communications told them to.

Jack was disgusted and told *The Examiner* that he could bear the situation no longer: he asked to be assigned to the Russian front, because he wanted to be home by the end of June. He was to depart much sooner: the situation deteriorated when one of his assistants caught a Japanese officer's groom stealing hay for his horses. The frustration that had been building up over the past four months exploded and he confronted the thief who, instead of apologizing, mocked him. Jack punched him, knocking him to the ground. But the Japanese were not prepared to tolerate such an incident. Moreover, of all the journalists, he had been the most unruly: arrested in Moji for having taken photographs, arrested again when he headed towards the front from Sunan and Ping Yang without permission and, for a considerable length of time, too insolent. An example was called for. Major General Fuji ordered his arrest and wanted to bring him before a court martial. The other correspondents sent a delegation in his defense, but the response was severe: "the honorable Mr London has violated the rules too many times." In fact Article 4 of the rules for war correspondents explicitly declared that they should be well dressed and behave properly and Article 5 stated that they should not offend the troops in any way. Mr London deserved the court martial that could also sanction the death sentence. It was only the intervention of Richard Harding Davis, who sent an urgent telegram to President Roosevelt, an admirer of the man and the writer, that saved Jack London, who was sent back to the United States: "Oh, my Darling, [...] Hurrah!

I'm coming home—coming home to you, to pillow my head on your breast and sleep for a while I think"[8].

Seismic waves

End of June 1904. Jack disembarked from the *SS Korea* in San Francisco, home again after almost six months. In his correspondence from Japan and Korea, his principal channel of communication had been with Charmian Kittredge, with whom he was already having an extra-marital affair. At home, he was sure he would find his wife Bess and his daughters Joan and Becky, but he was so focused on the future as far as his love life was concerned, that when he disembarked he hoped Charmian would be waiting for him. Instead, he was met by a letter from a lawyer. The headline in the *San Francisco Examiner*, the paper for which he had just finished writing his war correspondence, read: "Jack London sued by Wife." The accusations were serious and following the successes and excitement of 1903, 1904 was to prove a difficult year. Despite the huge success of *The Sea-Wolf* published that year, the only thing he was to write, apart from an insignificant play and some short stories, was the first book devoted to his beloved boxing, an art he practiced assiduously. The symptoms of his malaise were all present in *The Game* (published in 1905), one of his most beautiful stories, a dramatic plot that relates this sport as life and life as a struggle, in which love plays a key role. While, as usual, the critics found it offensive, the lightweight boxing champion Jimmy Britt described it as "an epic story of boxing." The work appeared to be an unwitting self-analysis. The protagonist, Joe

8. Letter to Charmian Kittredge, 1 June 1904, published in Earle Labor, *op. cit.*, p. 199.

Fleming, is a rising young boxer, with a boundless future ahead of him, thanks to the sport. Tragedy occurs when Joe dies in the ring on the eve of his wedding. It could not have been more symbolic. It was not the first nor the last time that Jack's avatar was to appear in the form of a character recalling his own path of psychic recognition. The rumblings of the earthquake and the shock waves that were to follow originated in his private life: on his return from the Russo-Japanese war, he regularly spent time with his daughters and he wrote to Charmian that he was often tempted to go back, for their sake: "but if I had gone back, it would have meant suicide or insanity." But everything was shifting towards what he would describe in *John Barleycorn* as "the long sickness", his indifference to life being summed up by the shocking phrase "I descended into my slough of despond [...]. I had life troubles and heart troubles [...]"[9].

In his exhaustive and unsurpassed biography of London (*Jack London. An American Life*, 2012), Earle Labor stresses that this aspect of Jack's psyche cannot be ignored if we wish to understand his artistic production at this time. His work never failed to probe deeply into the dark and mysterious ethereal place in which the hidden processes of the subconscious that determine man's role in the grand scheme of things are elaborated. He was not yet aware that in Switzerland, his close contemporary and explorer of the psyche, Carl Gustav Jung, was working on the revolution of man's perspective: he was to discover this ten years later, finding many answers to his questions and a new, incomplete path towards the revolution of the "human document." Failure to grasp that, to adopt Dostoyevsky's words in *Notes from Underground*, "consciousness is a disease" would be a gross error. The last few months of 1904 were difficult ones for

9. Jack London, *John Barleycorn. Alcoholic Memoirs*. The Project Gutenberg Etext, p. 67.

Jack, in fact he decided to give away his pistol. For the first time, but not the last, he realized that he had suicidal tendencies. This crisis at such a crucial age was a huge problem and his awareness is evident in this extract from a letter he wrote to Anna Strunsky, the other significant woman in his life: "Though a materialist when I first knew you ... I wander through life delivering hurt to all that know me"[10]. It was a turning point. He would emerge from this first earthquake as an adult alive, but the wounds would never heal. Jack was in bad shape physically, while his psychological vulnerability formed the basis of his illness. But he refused to surrender and, in December, his subconscious came to the rescue with the idea of writing *White Fang*, the perfect antithesis to *The Call of the Wild*: instead of the wild, Jack the Wolf sought domestic warmth and comfort. His psyche had spoken and, as always, Jack London the author would obey.

Jack continued along the path taken in "Hobo Land" in 1894, when he began to study as a socialist revolutionary. At the beginning of 1905, he met students from Berkeley University, California, and read them *Revolution*, his latest invective: "Seven million revolutionists, organized, working day and night, are preaching the revolution—that passionate gospel, the Brotherhood of Man. [...]. The capitalist class has been indicted. It has failed in its management and its management is to be taken away from it. [...]. The revolution is here, now. Stop it who can"[11]. But the long sickness did not slacken its hold, just as the bulldog Cherokee would not let go of White Fang's throat until someone came along and saved him from certain death by strangulation.

After the conferences and his torment, another earthquake

10. Letter to Anna Strunsky, published in Earle Labor, *op. cit.*, p. 207.

11. Jack London, excerpt from "Revolution" the opening essay of the volume *Revolution and other essays*, Macmillan 1909.

was about to strike, the shockwave of a new world. He sailed for several weeks on board the *Spray*, before being reunited with Charmian, in what did not seem to be a fortunate encounter. On Saturday 11 March, they went riding together. This was the day that the fault line began to open and lava to pour from it: "Away we rode together, he and I, one of us with a heavy heart... For I felt this was the last of Jack, that he was slipping irrecoverably from us who loved and would have helped him; and, what was more grave, slipping away from himself"[12]. The epiphany bore the features of Mother Earth. While they were crossing Nuns Canyon towards Napa, the Valley of the Moon was working its magical spell. "As we forged skyward on the ancient road that lies now against one bank, now another, the fanning ferns sprinkled our faces with rain and dew, wildflowers nodding in the cool flaws of wind, I could see [him] quicken and sparkle as if in spite of himself and the powers of darkness." That day Jack asked Charmian if she would move to a cabin up there, and help him with his work: "You did it all, my Mate-Woman. You've pulled me out. You've rested me so. And rest was what I needed—you were right. Something wonderful has happened to me. I am alright now... you need not be afraid for me any more"[13].

The following month, Jack and Charmian moved eighty kilometers north of San Francisco, because "In the Valley of the Moon, I found my paradise." Ten years later, he would fictionalize this paradise in one of his final masterpieces *The Valley of the Moon*. On 17 April 1905, Jack left the city for good and moved to Glen Ellen. By the end of May, he had decided to buy some land at Sonoma. Jack had a dream.

12. From Charmian Kittredge's journal, 11 March 1905; published in Earle Labor, *op. cit.*, pp. 216-217.

13. *Ibidem*, p. 217.

5:13 am. 18 April 1906. San Francisco

In November 1905, while he was in Ohio for a conference, Jack London received a telegram, notifying him of the end of his marriage to Bess Maddern. He was now free to remarry, but the date set for the following week seemed too long to wait: he sent a telegram to Charmian, asking her to join him immediately. The following evening he went to the station in Chicago to meet her, and when she got out of the train, he already had the marriage licence in his hand. However, it was a Sunday and London had to use the influence of the director of *Chicago American* magazine to drag the justice of the peace from his bed so that he could marry them. Not having even passed by the hotel, when they arrived the journalists were taken by surprise. Another snapshot of Jack "I would rather live" London showing how strong his lust for life and for everything in the future or on the horizon to be discovered was. The year of the tremors of love—for a woman, for life, for the Planet—ended on a high note, then slid into 1906 with conferences that roused the halls. But 1906 was also the year of the great San Francisco earthquake. At 5.13 on the morning of 18 April 1906, the city was almost entirely flattened by an earthquake of 8.3 magnitude. Fires raged for four days, destroying almost everything. At the very same moment, in their ranch in Sonoma Valley, Jack and Charmian were awoken by the tremors. They mounted their horses and rode to the top of Sonoma Mountain. Looking towards San Francisco, they were astonished to see that eighty kilometers to the south the sky was completely red. Santa Rosa, the capitol of Sonoma County, was also ablaze. In a letter written on 1 May, he was to report: "an hour after the quake, from a point high up in the mountains, we could see at the same time San Francisco and Santa Rosa burning. We took a train for Santa Rosa, where it was worse than in San Francisco. In the

afternoon we reached San Francisco by ferry and we spent the night following the fire"[14].

Naturally, Jack took his Kodak with him and captured the historic images of the hours immediately following the disaster. He would later return to document the city's slow recovery. Charmian, his Mate-Woman in every adventure, wrote: "we wandered the whole night through the city of the hills overwhelmed by emotions that are impossible to describe." It left an indelible mark on Jack. In 1912, when he published the prophetic short novel *The Scarlet Plague* (whose plot was to be taken up again in 2007 by Cormac McCarthy in his novel *The Road*) the post-apocalyptic setting is Frisco in 2013. Charmian asked Jack how he could possibly describe the disaster; he replied that there were no words to recount a similar situation: "I won't write about it all for anyone, no I can't write a single word. What use is trying? One can only put together a whole load of words and be frustrated at their futility." *Collier's*[15], however, begged and eventually managed to persuade him. He agreed, because at the ranch and the shipyard where the great dream of the *Snark* was being transformed into reality, his debts were accumulating (and, thanks to the earthquake, would continue to do so, leading him to the verge of bankruptcy). On 5 May 1906, a dry account, *The Story of an Eyewitness*, was published, the perfect vessel for the images in this book, some of the most powerful he ever took. Jack London the reporter was not satisfied with the vision that met his eyes on the 18 and 19 April and in order to understand the context, he left with Charmian for a ten day ride on horseback, reaching Fort

14. Extract from a letter written by Jack London on 1 May 1906 to Merle Maddern, the niece of his first wife, cit. in *Jack London, Photographer*, ed. Jeanne Campbell Reesman, Sara S. Hodson, Philip Adam, The University of Georgia Press 2010, p. 115.

15. From Charmian Kittredge's journal, cit. in *Jack London, Photographer*, *op. cit.*, p. 116.

Bragg, which had been completely destroyed by the earthquake.

A month later, he returned to San Francisco, visiting Berkeley and Oakland, his home town. Along the coast of San Mateo County, where he had lived as a child, he photographed the enormous landslides near to the present-day towns of Pacifica and Dale City. He was also to recount the story of other areas such as Marin, Sonoma and Mendocino Counties.

These photographs are considered by many to be the most beautiful and successful of his entire career. Let's try to imagine them as illustrations in a magazine that we are reading on 5 May 1906, only two weeks after the quake. We still have not seen anything—there was no television then—and so these photos will provide us with our first impression. We are immediately struck by the precision of the gaze, but also by its dismay and pain. The immensity, the scale and dimensions of the spaces portrayed remind us of the immensity, the scale and dimensions of the great city of San Francisco. In the century that has passed since his death, the value of London's photographs has not always been fully appreciated, a perception finally altered by the exhibition organized in San Francisco by the California Historical Society ("Jack London and the Great Earthquake and Firestorms of 1906") to mark the centenary of the earthquake. This exhibition led to the publication of *Jack London, Photographer*, by Jeanne Campbell Reesman, Sara Hodson and Philip Adam, in 2010, the first book ever to be devoted to London as a photographer, consisting of a selection drawn from over twelve thousand existing images.

The *Snark*

After two years of indescribable vicissitudes—skilfully recounted in the reportages that make up *The Cruise of the Snark*—on 23

April 1907, the *Snark*, a fourteen-metre sailing boat equipped with a seventy horsepower auxiliary engine and lifeboat, set sail from San Francisco heading for the southern Pacific Ocean. On board was a small crew, led by Jack and Charmian London. The couple's intention was to sail for seven years and to explore the seas. According to Charmian, Jack had come up with the idea a couple of years earlier, during a public reading for children of Joshua Slocum's book *Sailing Alone Around the World*, "as he shut the book, he had that new idea in his eyes." This was how he reaffirmed his idea: "I'd rather win a water-fight in the swimming pool, or remain astride a horse that is trying to get out from under me, than write the great American novel. Each man to his liking. [...] That is why I'm building the *Snark*. [...] The trip around the world means big moments of living."

It is difficult to believe how much Jack London managed to achieve between April 1906 and December 1907, when he was forced to throw in the towel due to problems with his health. From an artistic perspective, while he was on board the *Snark*, as well as a series of articles, he also wrote "Success", which in 1909 became *Martin Eden*, a great American novel, the epitaph of individualism. The next two years, 1907 and 1908, were to be fundamental in his literary production, considering that, without realizing it, in his own personal life and those he recounted in his books, he was writing the great American novel directly from life. *Martin Eden* became the turning point, that marks the beginning of the last eight years of his life and literary career, a novel that was misunderstood and that even now in the United States still does not enjoy the status of London's other great works.

As the photographs in this book show, the voyage undertaken by Jack and Charmian and then abruptly interrupted, was the perfect combination of the adventure of discovery and of cultural enrichment: direct contact with other peoples

broadened their horizons and in Jack provoked further inner turmoil. The man and the writer known for having described the power of the "blond-beast with blue eyes", the Anglo-Saxon who in the nineteenth century had conquered the world colonizing nations and continents, began to withdraw. At the beginning of his career, London had discovered in the Great North the perfect setting in which to stage his vision of the world. But from then onwards, the Great North was to become the Great South—the seas in whose immensity and contradictions authors such as Melville, Stevenson and Conrad (Jack's literary heroes) had already reflected their souls: the South Seas were home to the last "savages" who were attempting to resist colonization, and, unlike the tales from the Yukon, the indigenous people enjoyed Jack London's unconditional empathy.

Which is what makes the "human documents" included in this collection so remarkable, the worthy conclusion to the period examined through four key stages in his life: firstly, Jack travels to London and in the capital of an idealized England, the truth destroys many convictions; then, during the Russo-Japanese war, the San Francisco earthquake and finally the Great South. The metamorphosis was complete and what had superficially been labelled as inconsistency was in reality his greatness: the ability to change and adapt that is part of a dynamic personality, a creature that evolved with an inner trajectory consisting of pain and difficulty, constantly prepared to challenge his own convictions. A man who would rather live than merely exist. And long sickness aside, Jack London would rather live. He survived and adapted to the world, offering a cultured reinterpretation of it in the explosive topicality of these photographs. He did this because he felt a part of this world and he felt close to and similar to these people. The reaction was immediate and, while he was sailing around the South Pacific on the *Snark* and enjoying adventure on the islands, just as he had done as a boy in

San Francisco Bay, the public became aware of this when he published his first tale about Hawaii, *The House of Pride*. The frontal attack on racism and colonialism was a powerful one. Up until then, almost no one had photographed natives portraying them as human beings and preserving their dignity. London treated them as individuals, and did not portray them for the consumption of an audience easily manipulated by the racial marketing of the mass media. On the contrary, the whites portrayed in the photos of the South Seas rarely seem healthy in appearance. The islands of the Pacific harbored the worst aspects of colonialism, leading white men to treat the natives as savages. Anthropologist Jane C. Desmond, in her 2001 book *Staging Tourism*, writes: "The organized development of tourism in Hawaii formed part of a broader European and American fascination with the exotic. It was the aestheticization of Imperialist expansion" [16].

We only have to read the first page of London's story devoted to the magnificent Hawaiian male surfers, to understand the shift in perspective, the admiration, the desire to learn from "primitives who were living in the past." And while everyone was rushing to photograph the savages before they disappeared, he and Charmain sought an encounter, something to learn and to share, a vision to develop on man's path. Eventually, returning home with over four thousand photos, he was to put together what was by far and away the greatest album in his collection.

After Hawaii, the *Snark* visited the Marquesas Islands, and Tuamotu, Tahiti, Samoa, Fiji, the New Hebrides, the Solomon Islands, the Gilbert Islands, before finally reaching Australia. Leaving Hawaii, the *Snark* also accomplished the feat of crossing the Pacific without sighting or touching land for eight hundred miles: a crossing that was considered impossible because of winds coming from the northwest and the southeast. But the

16. From *Jack London, Photographer, op. cit.*, p. 150.

voyage was not to last for seven years. The *Smark's* sailing days were over when, overwhelmed by tropical diseases, Jack London was admitted to hospital in Sydney in December 1907, just as his much loved and controversial work *The Iron Heel*, the first novel of political fiction ever written, was published by MacMillan. As always, it was while living that Jack discovered that he needed to slow down and, good humouredly, he surrendered: "there are many boats and many voyages, but only a ration of nails and I only have one body. I prescribed for myself the climate and environment where I have maintained my nervous balance. I have nothing else to add except this, namely a request to all my friends: please refrain from congratulating us for abandoning our voyage. We are broken-hearted"[17].

After all, this was also another fault-line to overcome, the point where the Earth reveals synclines and anticlines, allowing water to flow and magma to come forth. Everything was going smoothly. The project for a beautiful house in Glen Ellen was going ahead, the relationship between Jack's home-loving and adventurous sides was beginning to emerge: "It will be a usable house and a beautiful house, wherein the aesthetic guest can find comfort for his eyes as well as for his body. It will be a happy house—or else I'll burn it down. It will be a house of air and sunshine and laughter. These three cannot be divorced. Laughter without air and sunshine becomes morbid, decadent, demoniac"[18].

July 2015

17. Extract from a press release issued in Sydney in January 1909 and signed by Jack London. Cit. in *Jack London, Photographer, op. cit.*, p. 167.

18. From "The House Beautiful", in Jack London, *Revolution and Other Essays*, Macmillan 1909.

The descent into London's abyss

On 30 July 1902, Jack London set sail on the *Majestic*, bound for London. The idea was to stay in the British capital for a while and to begin gathering material on the vast poverty-stricken and working class neighborhoods of the East End. The plan was then to continue his journey towards South Africa, where, on behalf of the American Press Association, he was to report on the social situation in the country after the Boer War. For various reasons, the assignment in South Africa was cancelled and so the writer had all the time he needed to descend into the abyss of the East End and to devote himself to a project he had been considering for a long time.

Jack London was then 26 years old, a promising young author, and starting to come to the public's attention; in his soul, that rebellious and adventurous vein that he was to nurture throughout his life, and in his mind, the political ideas linked to the American Socialist movement. London was always to possess the existential necessity to be inside the reality he was relating and, in this case too, the first thing he did was to break down the barriers: he no longer wore the clothes of an external observer, but the tattered ones of a tramp and, in this new skin, he plunged into the maze of East London's narrow streets. He shared and experienced at his own expense the life of the British Empire's destitute and those living on the margins: squalid housing, hunger, poor food, nights spent sleeping rough. He was to stay for eighty-four days, and in a letter to Anna Strunsky, was to say about them: "My stomach will never forgive me for all the disgusting things I have forced it to swallow since I have been here and my soul the devastating despair that I have witnessed… I am exhausted, shocked, my nerves are shattered by all I have seen, the suffering that these sights have caused me… I am sickened by this hellish human abyss that is called the East End"[1]. He was to emerge from there, however, not only with a completed manuscript but also a substantial number of images snapped with the Kodak he had taken with him to record the faces and sites in the city's abyss.

The book *The People of the Abyss* appeared in 1903 in an edition that would also include many of his photos and which still constitutes an outstanding example of passionate reportage, capable of going beyond the boundaries of the genre to provide a heart rending reflection on human conditions in modern society. Years later, referring to this work, Jack London was to say: "Of all my books, the one I love the most is *The People of the Abyss*. No other work of mine contains as much of my heart and my youthful tears as that study on the degradation of the poor"[2].

1. From Joan London. *Jack London and His Times, an Unconventional Biography*, University of Washington Press, Seattle-London 1974, p. 240.

2. *Ivi*, p. 82.

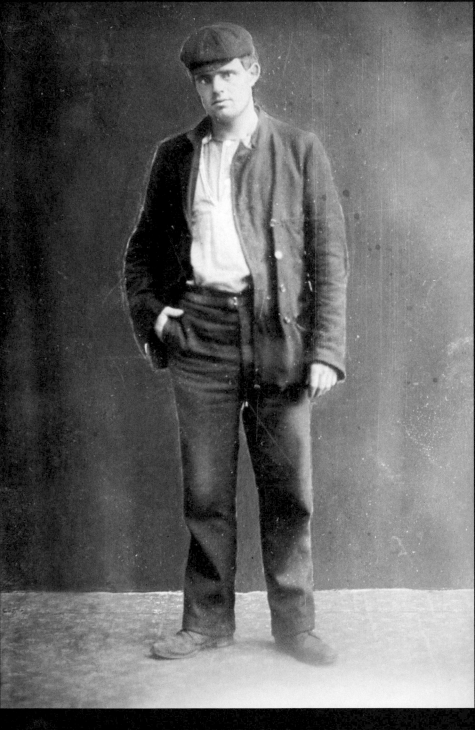

Jack London as an East Ender. London, 1902

The People of the Abyss

Preface

The experiences related in this volume fell to me in the summer of 1902. I went down into the under-world of London with an attitude of mind which I may best liken to that of the explorer. I was open to be convinced by the evidence of my eyes, rather than by the teachings of those who had not seen, or by the words of those who had seen and gone before. Further, I took with me certain simple criteria with which to measure the life of the under-world. That which made for more life, for physical and spiritual health, was good; that which made for less life, which hurt, and dwarfed, and distorted life, was bad.

It will be readily apparent to the reader that I saw much that was bad. Yet it must not be forgotten that the time of which I write was considered "good times" in England. The starvation and lack of shelter I encountered constituted a chronic condition of misery which is never wiped out, even in the periods of greatest prosperity.

Following the summer in question came a hard winter. Great numbers of the unemployed formed into processions, as many as a dozen at a time, and daily marched through the streets of London crying for bread. Mr. Justin McCarthy, writing in the month of January 1903, to the New York *Independent*, briefly epitomises the situation as follows:-

"The workhouses have no space left in which to pack the starving crowds who are craving every day and night at their doors for food and shelter. All the charitable institutions have exhausted their means in trying to raise supplies of food for the famishing residents of the garrets and cellars of London lanes and alleys. The quarters of the Salvation Army in various parts

of London are nightly besieged by hosts of the unemployed and the hungry for whom neither shelter nor the means of sustenance can be provided."

It has been urged that the criticism I have passed on things as they are in England is too pessimistic. I must say, in extenuation, that of optimists I am the most optimistic. But I measure manhood less by political aggregations than by individuals. Society grows, while political machines rack to pieces and become "scrap." For the English, so far as manhood and womanhood and health and happiness go, I see a broad and smiling future. But for a great deal of the political machinery, which at present mismanages for them, I see nothing else than the scrap heap.

Jack London
Piedmont, California

The chief priests and rulers cry:

"O Lord and Master, not ours the guilt,
We build but as our fathers built;
Behold thine images how they stand
Sovereign and sole through all our land.

Our task is hard—with sword and flame,
To hold thine earth forever the same,
And with sharp crooks of steel to keep,
Still as thou leftest them, thy sheep."

Then Christ sought out an artisan,
A low-browed, stunted, haggard man,
And a motherless girl whose fingers thin
Crushed from her faintly want and sin.

These set he in the midst of them,
And as they drew back their garment hem
For fear of defilement, "Lo, here," said he,
"The images ye have made of me."

James Russell Lowell

Chapter I

The Descent

Christ look upon us in this city,
And keep our sympathy and pity
Fresh, and our faces heavenward,
Lest we grow hard
Thomas Ashe

"But you can't do it, you know," friends said, to whom I applied for assistance in the matter of sinking myself down into the East End of London. "You had better see the police for a guide," they added, on second thought, painfully endeavouring to adjust themselves to the psychological processes of a madman who had come to them with better credentials than brains.

"But I don't want to see the police," I protested. "What I wish to do is to go down into the East End and see things for myself. I wish to know how those people are living there, and why they are living there, and what they are living for. In short, I am going to live there myself."

"You don't want to *live* down there!" everybody said, with disapprobation writ large upon their faces. "Why, it is said there are places where a man's life isn't worth tu'pence."

"The very places I wish to see," I broke in.

"But you can't, you know," was the unfailing rejoinder.

"Which is not what I came to see you about," I answered brusquely, somewhat nettled by their incomprehension. "I am a stranger here, and I want you to tell me what you know of

the East End, in order that I may have something to start on."

"But we know nothing of the East End. It is over there, somewhere." And they waved their hands vaguely in the direction where the sun on rare occasions may be seen to rise.

"Then I shall go to Cook's," I announced.

"Oh yes," they said, with relief. "Cook's will be sure to know."

But O Cook, O Thomas Cook & Son, path-finders and trail-clearers, living sign-posts to all the world, and bestowers of first aid to bewildered travellers—unhesitatingly and instantly, with ease and celerity, could you send me to Darkest Africa or Innermost Thibet, but to the East End of London, barely a stone's throw distant from Ludgate Circus, you know not the way!

"You can't do it, you know," said the human emporium of routes and fares at Cook's Cheapside branch. "It is so—hem—so unusual."

"Consult the police," he concluded authoritatively, when I had persisted. "We are not accustomed to taking travellers to the East End; we receive no call to take them there, and we know nothing whatsoever about the place at all."

"Never mind that," I interposed, to save myself from being swept out of the office by his flood of negations. "Here's something you can do for me. I wish you to understand in advance what I intend doing, so that in case of trouble you may be able to identify me."

"Ah, I see! should you be murdered, we would be in position to identify the corpse."

He said it so cheerfully and cold-bloodedly that on the instant I saw my stark and mutilated cadaver stretched upon a slab where cool waters trickle ceaselessly, and him I saw bending over and sadly and patiently identifying it as the body of the insane American who *would* see the East End.

"No, no," I answered; "merely to identify me in case I get into a scrape with the 'bobbies'." This last I said with a thrill; truly, I was gripping hold of the vernacular.

"That," he said, "is a matter for the consideration of the Chief Office."

"It is so unprecedented, you know," he added apologetically.

The man at the Chief Office hemmed and hawed. "We make it a rule," he explained, "to give no information concerning our clients."

"But in this case," I urged, "it is the client who requests you to give the information concerning himself."

Again he hemmed and hawed.

"Of course," I hastily anticipated, "I know it is unprecedented, but—"

"As I was about to remark," he went on steadily, "it is unprecedented, and I don't think we can do anything for you."

However, I departed with the address of a detective who lived in the East End, and took my way to the American consul-general. And here, at last, I found a man with whom I could "do business." There was no hemming and hawing, no lifted brows, open incredulity, or blank amazement. In one minute I explained myself and my project, which he accepted as a matter of course. In the second minute he asked my age, height, and weight, and looked me over. And in the third minute, as we shook hands at parting, he said: "All right, Jack. I'll remember you and keep track."

I breathed a sigh of relief. Having burnt my ships behind me, I was now free to plunge into that human wilderness of which nobody seemed to know anything. But at once I encountered a new difficulty in the shape of my cabby, a grey-whiskered and eminently decorous personage who had imperturbably driven me for several hours about the "City."

"Drive me down to the East End," I ordered, taking my seat.

"Where, sir?" he demanded with frank surprise.

"To the East End, anywhere. Go on."

The hansom pursued an aimless way for several minutes, then came to a puzzled stop. The aperture above my head was uncovered, and the cabman peered down perplexedly at me.

"I say," he said, "wot plyce yer wanter go?"

"East End," I repeated. "Nowhere in particular. Just drive me around anywhere."

"But wot's the haddress, sir?"

"See here!" I thundered. "Drive me down to the East End, and at once!"

It was evident that he did not understand, but he withdrew his head, and grumblingly started his horse.

Nowhere in the streets of London may one escape the sight of abject poverty, while five minutes' walk from almost any point will bring one to a slum; but the region my hansom was now penetrating was one unending slum. The streets were filled with a new and different race of people, short of stature, and of wretched or beer-sodden appearance. We rolled along through miles of bricks and squalor, and from each cross street and alley flashed long vistas of bricks and misery. Here and there lurched a drunken man or woman, and the air was obscene with sounds of jangling and squabbling. At a market, tottery old men and women were searching in the garbage thrown in the mud for rotten potatoes, beans, and vegetables, while little children clustered like flies around a festering mass of fruit, thrusting their arms to the shoulders into the liquid corruption, and drawing forth morsels but partially decayed, which they devoured on the spot.

Not a hansom did I meet with in all my drive, while mine was like an apparition from another and better world, the way the children ran after it and alongside. And as far as I could

see were the solid walls of brick, the slimy pavements, and the screaming streets; and for the first time in my life the fear of the crowd smote me. It was like the fear of the sea; and the miserable multitudes, street upon street, seemed so many waves of a vast and malodorous sea, lapping about me and threatening to well up and over me.

"Stepney, sir; Stepney Station," the cabby called down.

I looked about. It was really a railroad station, and he had driven desperately to it as the one familiar spot he had ever heard of in all that wilderness.

"Well," I said.

He spluttered unintelligibly, shook his head, and looked very miserable. "I'm a strynger 'ere," he managed to articulate. "An' if yer don't want Stepney Station, I'm blessed if I know wotcher do want."

"I'll tell you what I want," I said. "You drive along and keep your eye out for a shop where old clothes are sold. Now, when you see such a shop, drive right on till you turn the corner, then stop and let me out."

I could see that he was growing dubious of his fare, but not long afterwards he pulled up to the curb and informed me that an old-clothes shop was to be found a bit of the way back.

"Won'tcher py me?" he pleaded. "There's seven an' six owin' me."

"Yes," I laughed, "and it would be the last I'd see of you."

"Lord lumme, but it'll be the last I see of you if yer don't py me," he retorted.

But a crowd of ragged onlookers had already gathered around the cab, and I laughed again and walked back to the old-clothes shop.

Here the chief difficulty was in making the shopman understand that I really and truly wanted old clothes. But after

fruitless attempts to press upon me new and impossible coats and trousers, he began to bring to light heaps of old ones, looking mysterious the while and hinting darkly. This he did with the palpable intention of letting me know that he had "piped my lay," in order to bulldose me, through fear of exposure, into paying heavily for my purchases. A man in trouble, or a high-class criminal from across the water, was what he took my measure for—in either case, a person anxious to avoid the police.

But I disputed with him over the outrageous difference between prices and values, till I quite disabused him of the notion, and he settled down to drive a hard bargain with a hard customer. In the end I selected a pair of stout though well-worn trousers, a frayed jacket with one remaining button, a pair of brogans which had plainly seen service where coal was shovelled, a thin leather belt, and a very dirty cloth cap. My underclothing and socks, however, were new and warm, but of the sort that any American waif, down in his luck, could acquire in the ordinary course of events.

"I must sy yer a sharp 'un," he said, with counterfeit admiration, as I handed over the ten shillings finally agreed upon for the outfit. "Blimey, if you ain't ben up an' down Petticut Lane afore now. Yer trouseys is wuth five bob to hany man, an' a docker 'ud give two an' six for the shoes, to sy nothin' of the coat an' cap an' new stoker's singlet an' hother things."

"How much will you give me for them?" I demanded suddenly. "I paid you ten bob for the lot, and I'll sell them back to you, right now, for eight! Come, it's a go!"

But he grinned and shook his head, and though I had made a good bargain, I was unpleasantly aware that he had made a better one.

I found the cabby and a policeman with their heads together, but the latter, after looking me over sharply, and par-

ticularly scrutinizing the bundle under my arm, turned away and left the cabby to wax mutinous by himself. And not a step would he budge till I paid him the seven shillings and sixpence owing him. Whereupon he was willing to drive me to the ends of the earth, apologising profusely for his insistence, and explaining that one ran across queer customers in London Town.

But he drove me only to Highbury Vale, in North London, where my luggage was waiting for me. Here, next day, I took off my shoes (not without regret for their lightness and comfort), and my soft, grey travelling suit, and, in fact, all my clothing; and proceeded to array myself in the clothes of the other and unimaginable men, who must have been indeed unfortunate to have had to part with such rags for the pitiable sums obtainable from a dealer.

Inside my stoker's singlet, in the armpit, I sewed a gold sovereign (an emergency sum certainly of modest proportions); and inside my stoker's singlet I put myself. And then I sat down and moralised upon the fair years and fat, which had made my skin soft and brought the nerves close to the surface; for the singlet was rough and raspy as a hair shirt, and I am confident that the most rigorous of ascetics suffer no more than I did in the ensuing twenty-four hours.

The remainder of my costume was fairly easy to put on, though the brogans, or brogues, were quite a problem. As stiff and hard as if made of wood, it was only after a prolonged pounding of the uppers with my fists that I was able to get my feet into them at all. Then, with a few shillings, a knife, a handkerchief, and some brown papers and flake tobacco stowed away in my pockets, I thumped down the stairs and said good-bye to my foreboding friends. As I paused out of the door, the "help," a comely middle-aged woman, could not conquer a grin that twisted her lips and separated them

till the throat, out of involuntary sympathy, made the uncouth animal noises we are wont to designate as "laughter."

No sooner was I out on the streets than I was impressed by the difference in status effected by my clothes. All servility vanished from the demeanour of the common people with whom I came in contact. Presto! in the twinkling of an eye, so to say, I had become one of them. My frayed and out-at-elbows jacket was the badge and advertisement of my class, which was their class. It made me of like kind, and in place of the fawning and too respectful attention I had hitherto received, I now shared with them a comradeship. The man in corduroy and dirty neckerchief no longer addressed me as "sir" or "governor." It was "mate" now—and a fine and hearty word, with a tingle to it, and a warmth and gladness, which the other term does not possess. Governor! It smacks of mastery, and power, and high authority—the tribute of the man who is under to the man on top, delivered in the hope that he will let up a bit and ease his weight, which is another way of saying that it is an appeal for alms.

This brings me to a delight I experienced in my rags and tatters which is denied the average American abroad. The European traveller from the States, who is not a Croesus, speedily finds himself reduced to a chronic state of self-conscious sordidness by the hordes of cringing robbers who clutter his steps from dawn till dark, and deplete his pocket-book in a way that puts compound interest to the blush.

In my rags and tatters I escaped the pestilence of tipping, and encountered men on a basis of equality. Nay, before the day was out I turned the tables, and said, most gratefully, "Thank you, sir," to a gentleman whose horse I held, and who dropped a penny into my eager palm.

Other changes I discovered were wrought in my condition by my new garb. In crossing crowded thoroughfares I found

I had to be, if anything, more lively in avoiding vehicles, and it was strikingly impressed upon me that my life had cheapened in direct ratio with my clothes. When before I inquired the way of a policeman, I was usually asked, "Bus or 'ansom, sir?" But now the query became, "Walk or ride?" Also, at the railway stations, a third-class ticket was now shoved out to me as a matter of course.

But there was compensation for it all. For the first time I met the English lower classes face to face, and knew them for what they were. When loungers and workmen, at street corners and in public-houses, talked with me, they talked as one man to another, and they talked as natural men should talk, without the least idea of getting anything out of me for what they talked or the way they talked.

And when at last I made into the East End, I was gratified to find that the fear of the crowd no longer haunted me. I had become a part of it. The vast and malodorous sea had welled up and over me, or I had slipped gently into it, and there was nothing fearsome about it—with the one exception of the stoker's singlet.

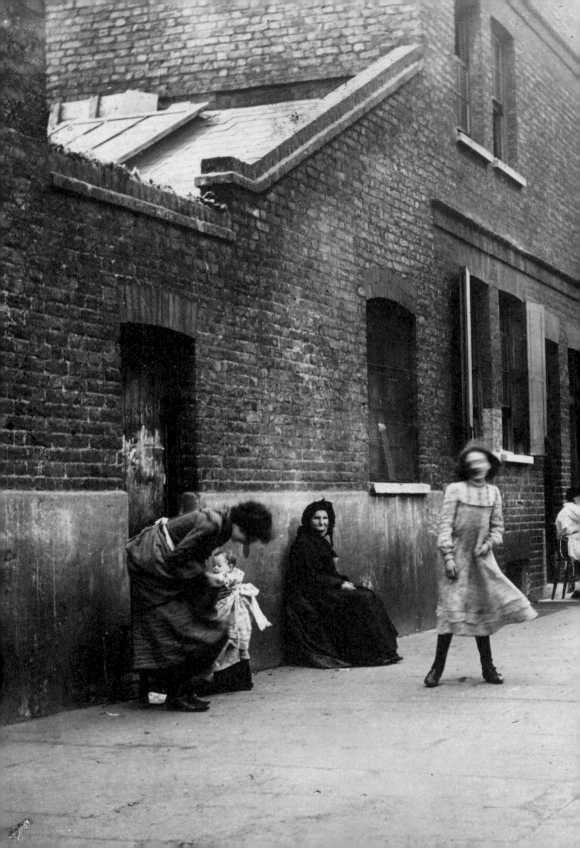

White Chapel on a Bank Holiday.
London, 1902

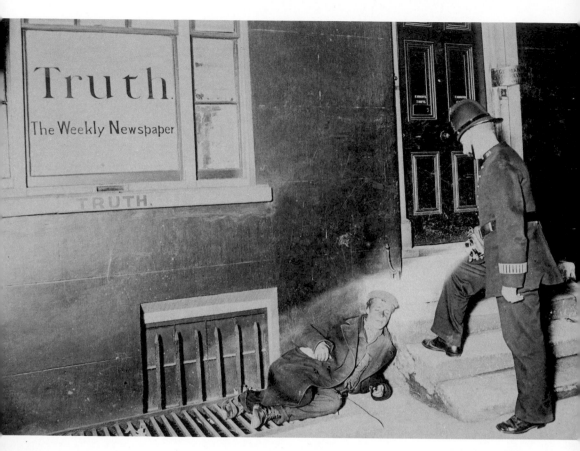

London, 1902

[...] And day by day I became convinced that not only is it unwise, but it is criminal for the people of the Abyss to marry. They are the stones by the builder rejected. There is no place for them, in the social fabric, while all the forces of society drive them downward till they perish. At the bottom of the Abyss they are feeble, besotted, and imbecile. If they reproduce, the life is so cheap that perforce it perishes of itself. The work of the world goes on above them, and they do not care to take part in it, nor are they able. Moreover, the work of the world does not need them. There are plenty, far fitter than they, clinging to the steep slope above, and struggling frantically to slide no more.

In short, the London Abyss is a vast shambles. Year by year, and decade after decade, rural England pours in a flood of vigorous strong life, that not only does not renew itself, but perishes by the third generation. Competent authorities aver that the London workman whose parents and grand-parents were born in London is so remarkable a specimen that he is rarely found. [...]

Chapter IV—*A Man and the Abyss*

[…] As I write this, and for an hour past, the air has been made hideous by a free-for-all, rough-and-tumble fight going on in the yard that is back to back with my yard. When the first sounds reached me I took it for the barking and snarling of dogs, and some minutes were required to convince me that human beings, and women at that, could produce such a fearful clamour.

Drunken women fighting! It is not nice to think of; it is far worse to listen to. Something like this it runs—

Incoherent babble, shrieked at the top of the lungs of several women; a lull, in which is heard a child crying and a young girl's voice pleading tearfully; a woman's voice rises, harsh and grating, "You 'it me! Jest you 'it me!" then, swat! challenge accepted and fight rages afresh. The back windows of the houses commanding the scene are lined with enthusiastic spectators, and the sound of blows, and of oaths that make one's blood run cold, are borne to my ears. […]

Sufficient affirmation on both sides, conflict again precipitated. One combatant gets overwhelming advantage, and follows it up from the way the other combatant screams bloody murder. Bloody murder gurgles and dies out, undoubtedly throttled by a strangle hold.

Entrance of new voices; a flank attack; strangle hold suddenly broken from the way bloody murder goes up half an octave higher than before; general hullaballoo, everybody fighting. Lull; new voice, young girl's, "I'm goin' ter tyke my mother's part;" dialogue, repeated about five times, "I'll do as I like, blankety, blank, blank!" "I'd like ter see yer, blankety, blank, blank!" renewed conflict, mothers, daughters, everybody, during which my landlady calls her young daughter in from the back steps, while I wonder what will be the effect of all that she has heard upon her moral fibre. […]

Chapter V—*Those on the Edge*

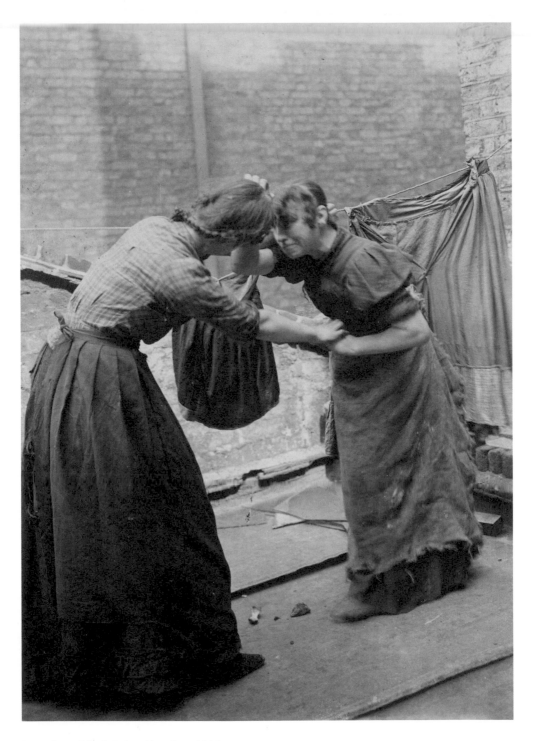

Drunken girls fighting. London, 1902

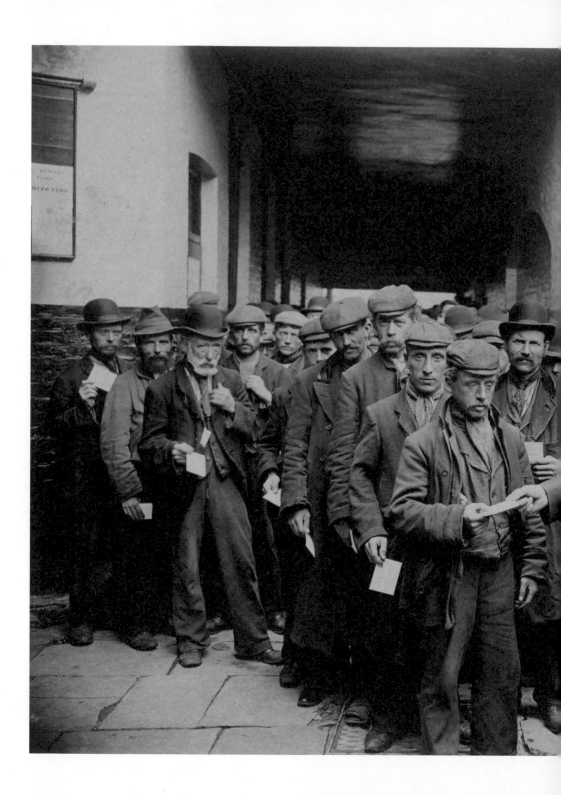

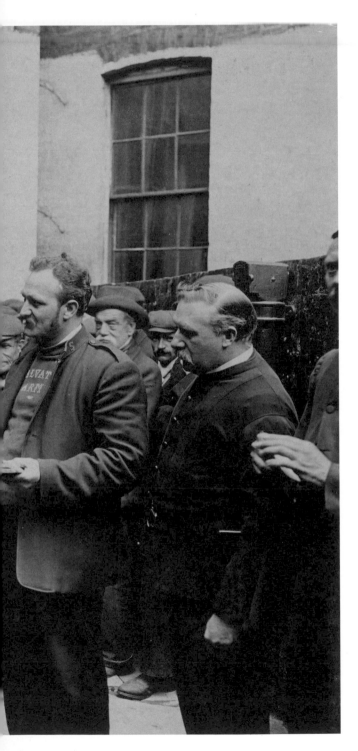

Court Yard Salvation Army Barracks Sunday Morning rush—men who had had tickets given them during the night for free breakfast. London, 1902

[...] I crossed the Waterloo Bridge to the Surrey side, cut across to Blackfriars Road, coming out near the Surrey Theatre, and arrived at the Salvation Army barracks before seven o'clock. This was "the peg." And by "the peg," in the argot, is meant the place where a free meal may be obtained.

Here was a motley crowd of woebegone wretches who had spent the night in the rain. Such prodigious misery! and so much of it! Old men, young men, all manner of men, and boys to boot, and all manner of boys. Some were drowsing standing up; half a score of them were stretched out on the stone steps in most painful postures, all of them sound asleep, the skin of their bodies showing red through the holes, and rents in their rags. And up and down the street and across the street for a block either way, each doorstep had from two to three occupants, all asleep, their heads bent forward on their knees. And, it must be remembered, these are not hard times in England. Things are going on very much as they ordinarily do, and times are neither hard nor easy. [...]

Chapter XI—*The Peg*

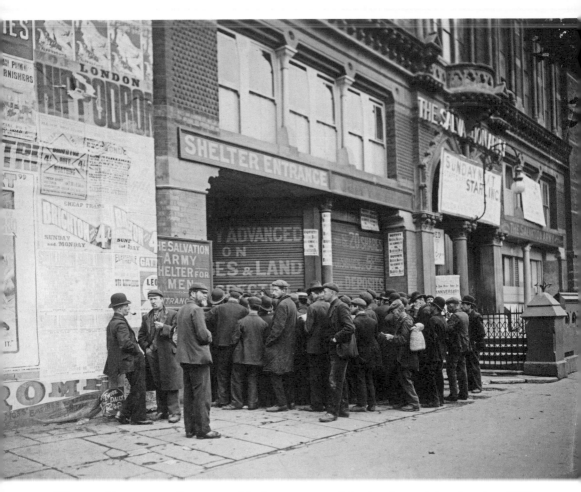

Weary and hungry men line up outside the entrance to Salvation Army shelter. London, 1902

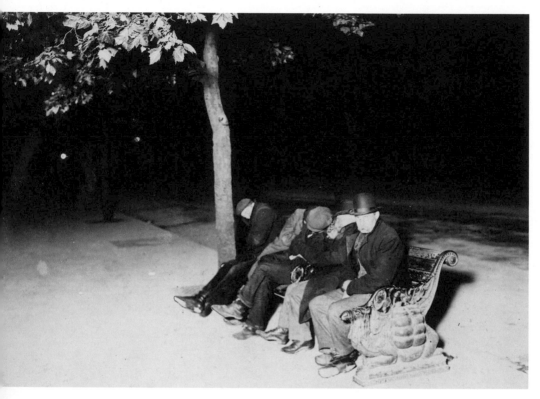

Men spending the night outdoors on the Thames embankment. London, 1902

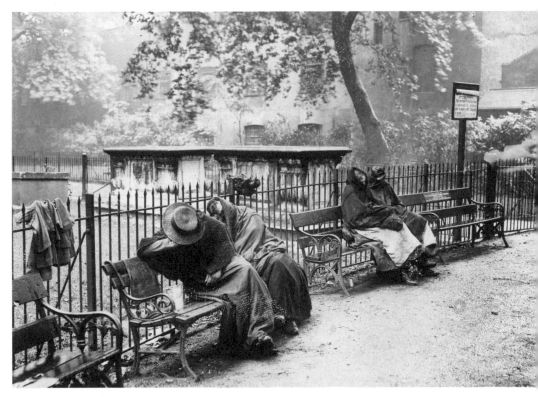

Spitafield's Garden. London, 1902

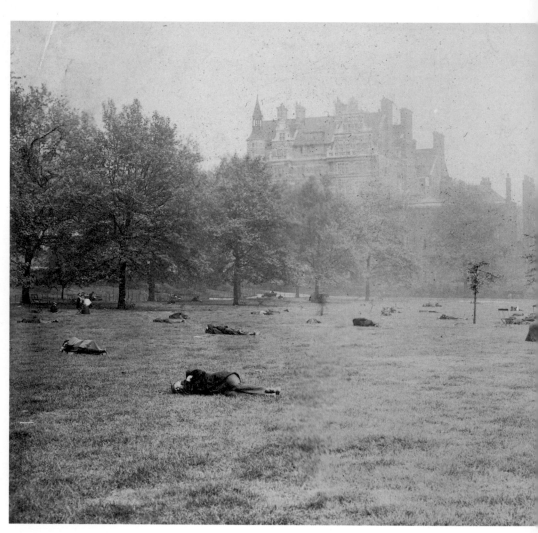

Green Park. London, 1902

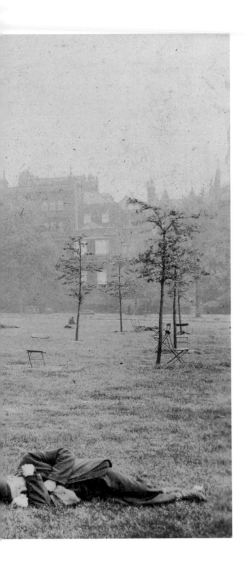

[...] Among those who carry the banner[1], Green Park has the reputation of opening its gates earlier than the other parks, and at quarter-past four in the morning, I, and many more, entered Green Park. It was raining again, but they were worn out with the night's walking, and they were down on the benches and asleep at once. Many of the men stretched out full length on the dripping wet grass, and, with the rain falling steadily upon them, were sleeping the sleep of exhaustion.

[...] In this connection, I will say that I came by Green Park that same day, at one in the afternoon, and that I counted scores of the ragged wretches asleep in the grass. It was Sunday afternoon, the sun was fitfully appearing, and the well-dressed West Enders, with their wives and progeny, were out by thousands, taking the air. It was not a pleasant sight for them, those horrible, unkempt, sleeping vagabonds; while the vagabonds themselves, I know, would rather have done their sleeping the night before.

And so, dear soft people, should you ever visit London Town, and see these men asleep on the benches and in the grass, please do not think they are lazy creatures, preferring sleep to work. Know that the powers that be have kept them walking all the night long, and that in the day they have nowhere else to sleep.

Chapter X—*Carrying the Banner*

1. Editor's note: The expression "to carry the banner" means to spend the night in the street, moving from one place to another. The expression is said to derive from the slang adopted by American typographers, who would roam the streets wearing the pennant of their guild to indicate that they were out of work.

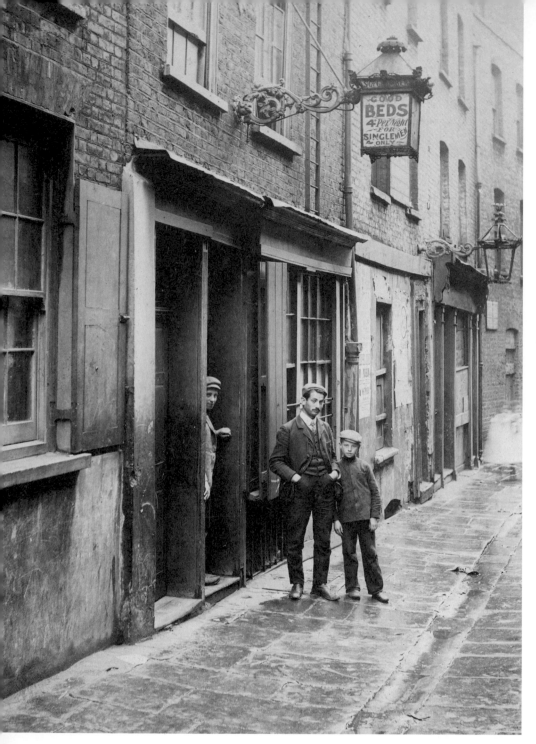

A lodging house. London, 1902

"An East End Slavey." London, 1902

London, 1902

"Where home is a hovel, and dull we grovel,
Forgetting the world is fair."

There is one beautiful sight in the East End, and only one, and it is the children dancing in the street when the organ-grinder goes his round. It is fascinating to watch them, the new-born, the next generation, swaying and stepping, with pretty little mimicries and graceful inventions all their own, with muscles that move swiftly and easily, and bodies that leap airily, weaving rhythms never taught in dancing school.

I have talked with these children, here, there, and everywhere, and they struck me as being bright as other children, and in many ways even brighter. They have most active little imaginations. Their capacity for projecting themselves into the realm of romance and fantasy is remarkable. A joyous life is romping in their blood. They delight in music, and motion, and colour, and very often they betray a startling beauty of face and form under their filth and rags.

But there is a Pied Piper of London Town who steals them all away. They disappear. One never sees them again, or anything that suggests them. You may look for them in vain amongst the generation of grown-ups. Here you will find stunted forms, ugly faces, and blunt and stolid minds. Grace, beauty, imagination, all the resiliency of mind and muscle, are gone. Sometimes, however, you may see a woman, not necessarily old, but twisted and deformed out of all womanhood, bloated and drunken, lift her draggled skirts and execute a few grotesque and lumbering steps upon the pavement. It is a hint that she was once one of those children who danced to the organ-grinder. Those grotesque and lumbering steps are all that is left of the promise of childhood. In the befogged recesses of her brain has arisen a fleeting memory that she was once a girl. The crowd closes in. Little girls are dancing beside her, about her, with all the pretty graces she dimly recollects, but can no more than parody with her body. Then she pants for breath, exhausted, and stumbles out through the circle. But the little girls dance on. [...]

Chapter XXIII—*The Children*

Next pages: "Result of putting up a stand camera in a Court Jewish Quarters." London, 1902

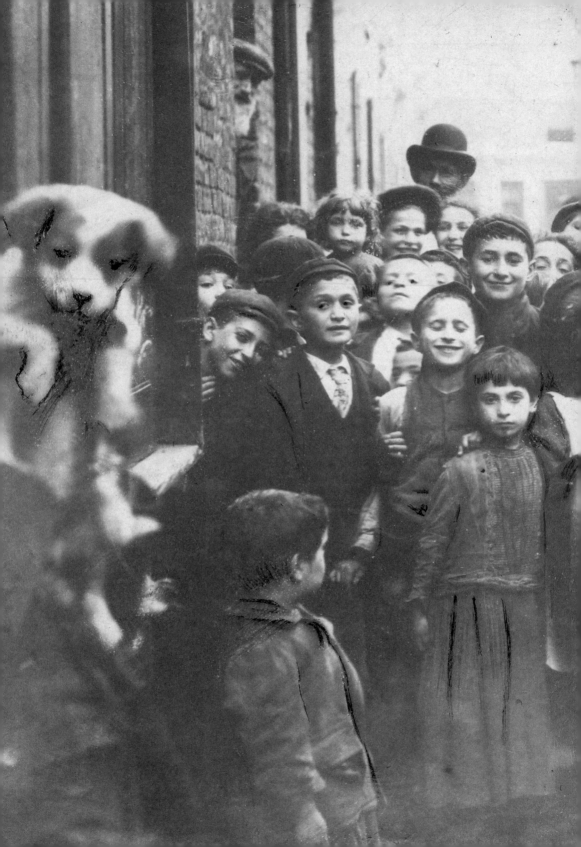

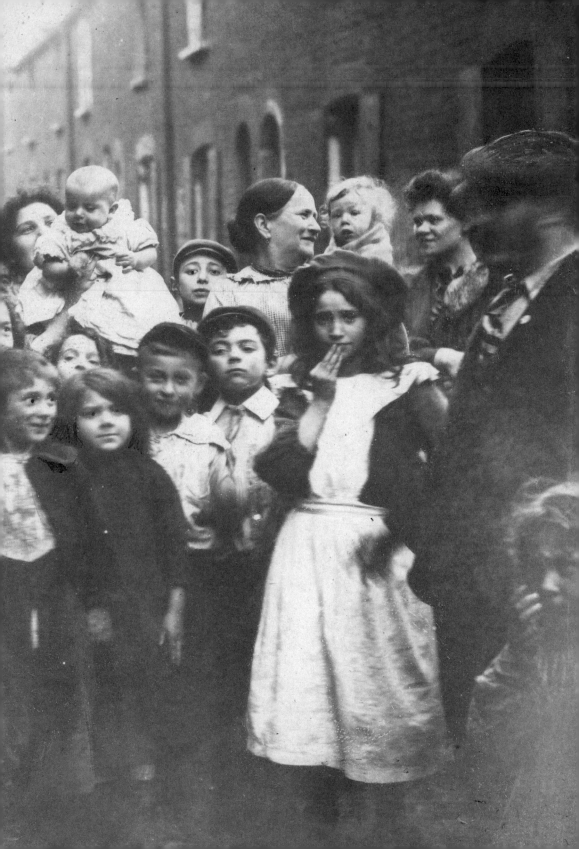

The Russo Japanese War, 1904

By the end of 1903, Jack London was already a successful writer. That year he had published two masterpieces, *The People of the Abyss* and, a few months later, what was to become his greatest triumph of the time, *The Call of the Wild*. So as the conflict between Russia and Japan was brewing, as one of the most popular writers of the moment, he was invited by several newspapers to go to the front as a war correspondent. The most attractive proposal came from the *San Francisco Examiner*, and on 7 January 1904, London set off on its behalf, heading for Korea.

War broke out on 9 February, when Japan attacked the Russian naval base in Port Arthur. London had taken with him his camera, which was to lead to many problems for him with the Japanese authorities, thanks to the mysterious and complicated censorship rules which would result in his arrest and hours of interrogation, under the accusation of being a Russian spy. His only real crime, however, was to have taken some photos of people in the street.

The months spent in Korea were to prove frustrating for the writer, given the Japanese army's cast-iron insistence on keeping correspondents away from the battle zone. Despite this, London was to become the most celebrated correspondent of this war, managing to send approximately twenty articles (a couple of which are published here) and hundreds of photos that reached the public via the pages of the *San Francisco Examiner*. These images still constitute a remarkable testimony of what Jack referred to as the "human documents" of the war; caught in the mesh of censorship, he directed his camera behind the front line and depicted the inhabitants of villages and soldiers, families of refugees and laborers. In Korea, he also produced two series of portraits, one devoted to the old men of a village, the other to children made homeless by the war, providing once again proof of his absolute mastery of the photographic language and the intensity of his gaze on reality.

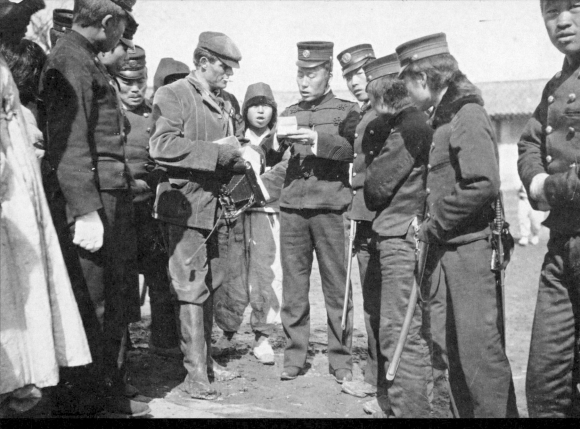

Jack London detained by Japanese officials in Korea, 1904

How Jack London Got In and Out of Jail in Japan

Shimonoseki, Wednesday, February 3, 1904

I journeyed all day from Yokohama to Kobe to catch a steamer for Chemulpo, which last city is on the road to Seoul. I journeyed all day and all night from Kobe to Nagasaki to catch a steamer for Chemulpo. I journeyed back all day from Nagasaki to Moji to catch a steamer for Chemulpo. On Monday morning, in Moji, I bought my ticket for Chemulpo, to sail on Monday afternoon. To-day is Wednesday, and I am still trying to catch a steamer for Chemulpo. And thereby hangs a tale of war and disaster, which runs the gamut of the emotions from surprise and anger to sorrow and brotherly love, and which culminates in arrest, felonious guilt and confiscation of property, to say nothing of monetary fines or alternative imprisonment.

For know that Moji is a fortified place, and one is not permitted to photograph "land or water scenery." I did not know it, and I photographed neither land nor water scenery; but I know it now just the same.

Having bought my ticket at the Osaka Shosen Kaisha office, I tucked it into my pocket and stepped out the door. Came four coolies carrying a bale of cotton. Snap went my camera. Five little boys at play-snap again. A line of coolies carrying coal-and again snap, and last snap. For a middle-aged Japanese man, in European clothes and great perturbation, fluttered his hands prohibitively before my camera. Having performed this function, he promptly disappeared.

"Ah, it is not allowed," I thought, and, calling my rickshaw-man, I strolled along the street.

Later, passing by a two-story frame building, I noticed my middle-aged Japanese standing in the doorway. He smiled and beckoned me to enter. "Some chin-chin and tea," thought I, and obeyed. But alas! it was destined to be too much chin-chin and no tea at all. I was in the police station. The middle-aged Japanese was what the American hobo calls a "fly cop."

Great excitement ensued. Captains, lieutenants and ordinary policemen all talked at once and ran hither and thither. I had run into a hive of blue uniforms, brass buttons and cutlasses. The populace clustered like flies at doors and windows to gape at the "Russian spy." At first it was all very ludicrous—"capital to while away some of the time ere my steamer departs," was my judgment; but when I was taken to an upper room and the hours began to slip by, I decided that it was serious.

I explained that I was going to Chemulpo. "In a moment," said the interpreter. I showed my ticket, my passport, my card, my credentials; and always and invariably came the answer, "In a moment." Also, the interpreter stated that he was very sorry. He stated this many times. He made special trips upstairs to tell me he was very sorry. Every time I told him I was going to Chemulpo he expressed his sorrow, until we came to vie with each other, I in explaining my destination, he in explaining the state and degree of his emotion regarding me and my destination.

And so it went. The hour of tiffin had long gone by. I had had an early breakfast. But my appetite waited on his "In a moment" till afternoon was well along. Then came the police examination, replete with searching questions concerning myself, my antecedents, and every member of my family. All of which information was

gravely written down. An unappeasable interest in my family was displayed. The remotest relatives were hailed with keen satisfaction and placed upon paper. The exact ascertainment of their antecedents and birthplaces seemed necessary to the point at issue, namely, the snaps I had taken of the four coolies carrying cotton, the five little boys playing and the string of coal coolies.

Next came my movements since my arrival in Japan.

"Why did you go to Kobe?"

"To go to Chemulpo," was my answer. And in this fashion I explained my presence in the various cities of Japan. I made manifest that my only reason for existence was to go to Chemulpo; but their conclusion from my week's wandering was that I had no fixed place of abode. I began to shy. The last time the state of my existence had been so designated it had been followed by a thirty-day imprisonment in a vagrant's cell![1] Chemulpo suddenly grew dim and distant, and began to fade beyond the horizon of my mind.

"What is your rank?" was the initial question of the next stage of examination.

I was nobody, I explained, a mere citizen of the United States; though I felt like saying that my rank was that of traveler for Chemulpo. I was given to understand that by rank was meant business, profession.

"Traveling to Chemulpo," I said was my business; and when they looked puzzled I meekly added that I was only a correspondent.

Next, the hour and the minute I made the three exposures. Were they of land and water scenery? No, they

1. A reference to his experiences as a tramp in 1894. He records these in his book *The Road*. He was arrested in Niagara for vagrancy and sentences to thirty days in the Erie County Penitentiary.

were of people. What people? Then I told of the four coolies carrying cotton, the five small boys playing and the string of coal coolies. Did I stand with my back to the water while making the pictures? Did I stand with my back to the land? Somebody had informed them that I had taken pictures in Nagasaki (a police lie, and they sprang many such on me). I strenuously denied. Besides it had rained all the time I was in Nagasaki. What other pictures had I taken in Japan? Three-two of Mount Fuji, one of a man selling tea at a railway station. Where were the pictures? In the camera, along with the four coolies carrying cotton, the five small boys playing and the string of coal coolies? Yes.

Now, about those four coolies carrying cotton, the five small boys playing and the string of coal coolies? And then they threshed through the details of the three exposures, up and down, back and forth, and crossways, till I wished that the coal coolies, cotton coolies and small boys had never been born. I have dreamed about them ever since, and I know I shall dream about them until I die.

Why did I take pictures? Because I wanted to. Why did I want to? For my pleasure. Why for my pleasure?

Pause a moment, gentler reader, and consider. What answer could you give to such a question concerning any act you have ever performed? Why do you do anything? Because you want to; because it is your pleasure. An answer to the question, "Why do you perform an act for your pleasure?" would constitute an epitome of psychology. Such an answer would go down to the roots of being, for it involves impulse, volition, pain, pleasure, sensation, grey matter, nerve fibers, free will and determinism, and all the vast fields of speculation wherein

man has floundered since the day he dropped down out of the trees and began to seek out the meaning of things.

And I, an insignificant traveler on my way to Chemulpo, was asked this question in the Moji police station through the medium of a seventh-rate interpreter. Nay, an answer was insisted upon. Why did I take the pictures because I wanted to, for my pleasure? I wished to take them—why? Because the act of taking them would make me happy. Why would the act of taking them make me happy? Because it would give me pleasure. But why would it give me pleasure? I hold no grudge against the policeman who examined me at Moji, yet I hope that in the life to come he will encounter the shade of Herbert Spencer and be informed just why, precisely, I took the pictures of the four coolies carrying cotton, the five small boys playing and the string of coal coolies.

Now, concerning my family, were my sisters older than I or younger? The change in the line of questioning was refreshing, even though it was perplexing. But ascertained truth is safer than metaphysics, and I answered blithely. Had I a pension from the government? A salary? Had I a medal of service? Of merit? Was it an American camera? Was it instantaneous? Was it mine?

To cut a simple narrative short, I pass on from this sample of the examination I underwent to the next step in the proceedings, which was the development of the film. Guarded by a policeman and accompanied by the interpreter, I was taken through the streets of Moji to a native photographer. I described the location of the three pictures of the film of ten. Observe the simplicity of it. These three pictures he cut out and developed, the seven other exposures, or possible exposures, being returned to me undeveloped. They might have contained the secret

of the fortifications of Moji for all the policemen knew; and yet I was permitted to carry them away with me, and I have them now. For the peace of Japan, let me declare that they contain only pictures of Fuji and tea-sellers.

I asked permission to go to my hotel and pack my trunks—in order to be ready to catch the steamer for Chemulpo. Permission was accorded, and my luggage accompanied me back to the police station, where I was again confined in the upper room listening to the "In a moments" of the interpreter and harping my one note that I wanted to go to Chemulpo.

In one of the intervals the interpreter remarked, "I know great American correspondent formerly."

"What was his name?" I asked, politely.

"Benjamin Franklin," came the answer; and I swear, possibly because I was thinking of Chemulpo, that my face remained graven as an image.

The arresting officer now demanded that I should pay for developing the incriminating film, and my declining to do so caused him not a little consternation.

"I am very sorry," said the interpreter, and there were tears in his voice; "I inform you cannot go to Chemulpo. You must go to Kokura."

Which last place I learned was a city a few miles in the interior.

"Baggage go?" I asked.

"You pay?" he countered.

I shook my head.

"Baggage go not," he announced.

"And I go not," was my reply.

I was led downstairs into the main office. My luggage followed. The police surveyed it. Everybody began to talk at once. Soon they were shouting. The din was terrific,

the gestures terrifying. In the midst of it I asked the interpreter what they had decided to do, and he answered, shouting to make himself heard, that they were talking it over.

Finally rickshaws were impressed, and bag and baggage transferred to the depot. Alighting at the depot at Kokura, more delay was caused by my declining to leave my luggage in the freight office. In the end it was carted along with me to the police station, where it became a spectacle for the officials.

Here I underwent an examination before the Public Procurator of the Kokura District Court. The interpreter began very unhappily, as follows:

"Customs different in Japan from America; therefore you must not tell any lies."

Then was threshed over once again all the details of the four coolies carrying cotton, the five small boys playing and the string of coal coolies; and I was committed to appear for trial next morning.

And next morning, bare-headed, standing, I was tried by three solemn, black-capped judges. The affair was very serious. I had committed a grave offense, and the Public Procurator stated that while I did not merit a prison sentence, I was nevertheless worthy of a fine.

After an hour's retirement the judges achieved a verdict. I was to pay a fine of five yen, and Japan was to get the camera. All of which was eminently distasteful to me, but I managed to extract a grain of satisfaction from the fact that they quite forgot to mulct me of the five yen. There is trouble brewing for somebody because of those five yen. There is the judgment. I am a free man. But how are they to balance accounts?

In the evening at the hotel the manager, a Japanese,

handed me a card, upon which was transcribed: Reporter of the "Osaka Asahi Shimbun." I met him in the reading-room, a slender, spectacled, silk-gowned man, who knew not one word of English. The manager acted as interpreter. The reporter was very sorry for my predicament. He expressed the regret of twenty other native correspondents in the vicinity, who in turn, represented the most powerful newspapers in the empire. He had come to offer their best offices; also to interview me.

The law was the law, he said, and the decree of the court could not be set aside; but there were ways of getting around the law. The voice of the newspapers was heard in the land. He and his fellow correspondents would petition the Kokura judges to auction off the camera, he and his associates to attend and bid it in at a nominal figure. Then it would give them the greatest pleasure to present my camera (or the Mikado's, or theirs) to me with their compliments.

I could have thrown my arms about him then and there—not for the camera, but for brotherhood, as he himself expressed it the next moment, because we were brothers in the craft. Then we had tea together and talked over the prospects of war. The nation of Japan he likened to a prancing and impatient horse, the Government to the rider, endeavoring to restrain the fiery steed. The people wanted war; the newspapers wanted war, public opinion clamored for war; and war the Government would eventually have to give them.

We parted as brothers part, and without wishing him any ill-luck, I should like to help him out of a hole some day in the United States. And here I remain in my hotel wandering if I'll ever see my camera again and trying to find another steamer for Chemulpo.

P. S.—Just received a dispatch from the United States Minister at Tokio. As an act of courtesy, the Minister of Justice will issue orders to-day to restore my camera!

P. S.—And a steamer sails to-morrow from Chemulpo.

Japanese Officers Consider Everything a Military Secret

Antung (First Japanese Army), June 2, 1904

It is all very well, this long-range fighting; but if the range continues to increase, and if other armies are as solicitous for the welfare of the correspondents as are the Japanese, war correspondence will become a lost art and there will be a lot of war correspondents entering new professions late in life.

In the first place, when the front of battle extends for miles and miles, no correspondent can see of his own eyes all that is taking place. What is happening to the right, miles away, behind the mountains where the Yalu curls into the east, and what is happening to the left, miles away, behind the mountains where the Yalu curls into the west, is beyond him. He cannot understand what is taking place before his eyes (or his field-glasses, rather, for his eyes show him nothing), without knowing what is taking place on right and left; and there is no one to tell him what is taking place on right and left. The officers may not tell him, because, in their parlance, it would be an exposure of a military secret.

This would not be so bad if they did not consider practically everything a military secret. Apropos of this, a correspondent, on his way up country, arrives at the village of Kasan. A skirmish had once taken place at Kasan. A month had passed. The front had moved up a hundred miles. The correspondent saw a few graves on the hillside. "How many Japanese were killed?" he asked an officer. The officer was a major. He replied, "I cannot tell you. It is a military secret."

The above may seem far-fetched, but it is not. It is

merely typical. On every side is the military secret. The correspondent is hedged around by military secrets. He may not move about for fear he will pop on to a military secret, though what he may do with a military secret only the Japanese know. First, in order to get a military secret out of the country, he must show it to the censor and get permission. This obtained, he must dispatch it by Korean-runners to Ping Yang, a couple of hundred miles to the south, where it may be telegraphed by his agent to Seoul and from there be cabled, via Japan, to his paper. But granting that the military secret has survived all the vicissitudes of the journey to Ping Yang and not lost its time-value, it is not yet out of the country. Seven or eight days later a runner arrives with a note from his Ping Yang agent telling him that all cables are being held up. So the military secret, like the peasant who started for Carcassonne, dies unobtrusively of old age upon the way.

The position of the correspondent in the Japanese army is an anomalous one of interloper and honored guest. The restrictions which stultify all his efforts show the one, the solicitude of his hosts shows the second. If a skirmish or demonstration is to be made, word is sent to him to that effect—also, a further word to the effect that he is to assemble with his colleagues at a certain place and proceed and be directed under the management of an army officer told off for the purpose. He is further warned that neither he nor his colleagues may go individually. Still further, he has fresh in his mind the previous day's instructions from headquarters as, for instance, those of April 29th, from which I quote the following:

"There is no official news to communicate concerning military operations now proceeding or pending.

Headquarters (unofficially) is aware that artillery has been engaged on both sides of the river.

For the present and until further notice the transmission of any dispatches from the front where wireless telegraphy is employed is forbidden. The necessary steps are being taken to see that this order is obeyed.

It may be found necessary to enforce a still stricter censorship than that already existing.

From to-day and until further notice it is forbidden to take photographs or make sketches of any kind within the area now occupied by the Japanese troops. It is useless to apply for permission to do so, as applications of this kind will not be entertained.

Correspondents may witness all military operations. They must keep well in the rear of the firing line. They are forbidden to approach certain (unspecified) works."

The peculiar force of this last order lies in that the correspondent who ventures out for a "look see" all by himself finds that just about everything in the landscape is unspecifiedly forbidden. The nearest I have succeeded in getting to a Japanese battery, and one not in action either, was when I crawled to the top of a hill half a mile to the rear and gazed upon it through field-glasses in fear and trembling.

Even before the taking of photographs was absolutely forbidden I once had the temerity to take a snap of an army farrier and his bellows. "Here at last was something that was not a military secret," I had thought in my innocence. Fifteen minutes' ride away I was stopped by a soldier who could not speak English. I showed my credentials and on my arm the official insignia of my position in the Japanese army. But it was no use. Something serious

was pending. I was ordered to remain where I was, and while I waited I cudgeled my brains in an endeavor to find what military secret had crept in unawares.

I did not know of any, but I was confident that one was there somewhere. After much delay an officer was brought to me. He was a captain, and his English was excellent—a great deal purer and better than my own.

"You have taken a photograph of an army blacksmith," he said accusingly and reproachfully.

With a sinking heart I nodded my head to acknowledge my guilt.

"You must give it up," he said.

"It is ridiculous," I burst out.

"You must give it up," he repeated.

Then after some discussion with the soldiers, he said I might keep it; but he added that the road was one of the unspecified forbidden places, and that I must go back. Back I went, but the field telephone must have beaten me, for they knew all my transgression at headquarters before I got there.

The functions of the war correspondent, so far as I can ascertain, is to sit up on the reverse slopes of hills where honored guests cannot be injured, and from there to listen to the crack of rifles and vainly search the dim distance for the men who are doing the shooting; to receive orders from headquarters as to what he may or may not do; to submit daily to the censor his conjectures and military secrets, and to observe article 4 of the printed First Army Regulations—to wit:

"Press correspondents should look and behave decently, and should never do anything disorderly, and should never enter the office rooms of the headquarters."

With one exception, the correspondents with the first

army are what is called "cable" men. Theirs is the task to cable, telegraph, use runners and whatever means to hand to get news out of the country as quickly as possible. There is the censor to begin with. What little news they do manage to glean is pretty well emasculated by him before it is allowed to start. At the very earliest it will arrive in Japan five days later. From Japan it radiates to the rest of the world. But the headquarters is connected directly with Tokio by wire. That is to say, the headquarters news beats the correspondents' news to Tokio by five days. Not only that, for it has full details and is correct. In addition, the powers that be at Tokio are more liberal than the first army censor, so that Tokio makes public to the world a full account five days before the "cable" men's accounts begin to arrive. If other nations in future wars imitate the Japanese in this, the "cable" men would cease to exist. There would be no reason for them to exist. The regular news-gatherers in the capitals of the contending countries would serve the purpose just as well and a great deal better.

Remains the writing man. Long-range fighting, supervising officers who lead him about in the rear as Cook's tourists are led about Rome and Paris, military secrets, and censors do for him. When he has described two or three invisible battles and has had his conjectures trimmed down by the censor, he is done for. He can't go on describing the sound of rifles and guns, the bursting of shell and shrapnel, and the occasional moving specks for a whole campaign. Nor can he go on describing the transport trains in the rear, the only things he sees too much of and which, as yet, have not been placed under the taboo of military secret.

Personally, I entered upon this campaign with the most gorgeous conceptions of what a war correspondent's

work in the world must be. I knew that the mortality of war correspondents was said to be greater, in proportion to numbers, than the mortality of soldiers. I remembered, during the siege of Khartoum and the attempted relief by Wolseley, the deaths in battle of a number of correspondents. I had read "The Light that Failed." I remember Stephen Crane's descriptions of being under fire in Cuba. I had heard—God wot, was there aught I had not heard?—of all sorts and conditions of correspondents in all sorts of battles and skirmishes, right in the thick of it, where life was keen and immortal moments where being lived. In brief, I came to war expecting to get thrills. My only thrills have been those of indignation and irritation.

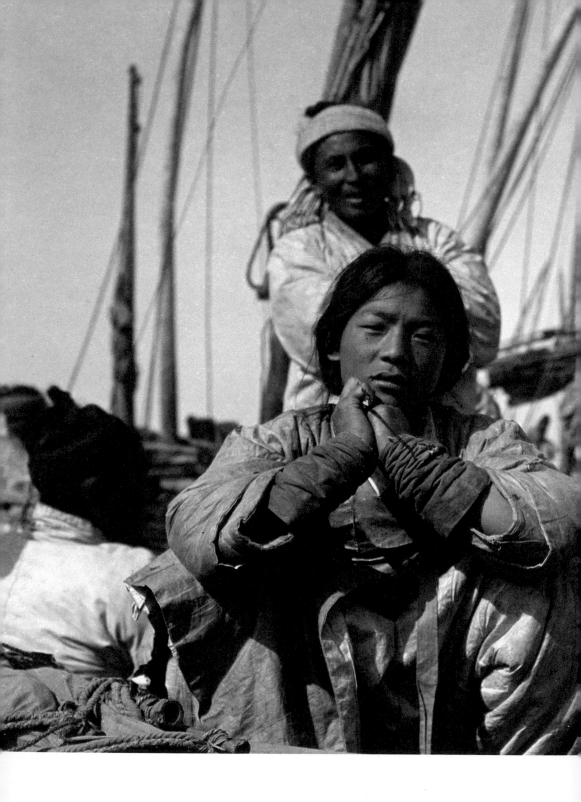

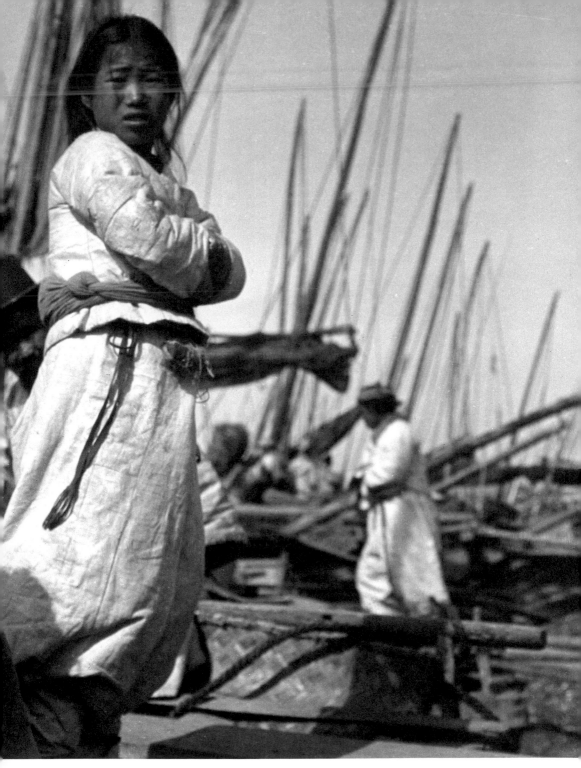

Antung Harbor, Manchuria, 1904

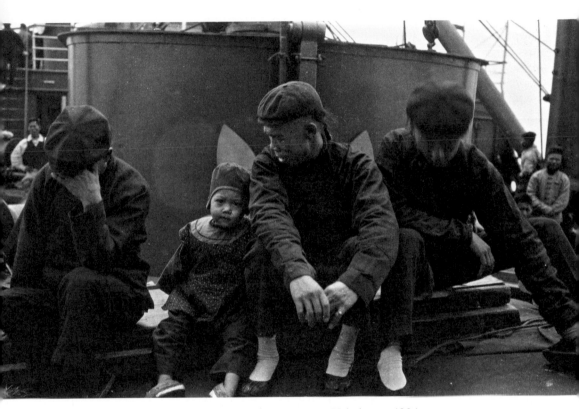

Fellow passengers to Japan, S.S. Siberia en route to Yokohama, 1904

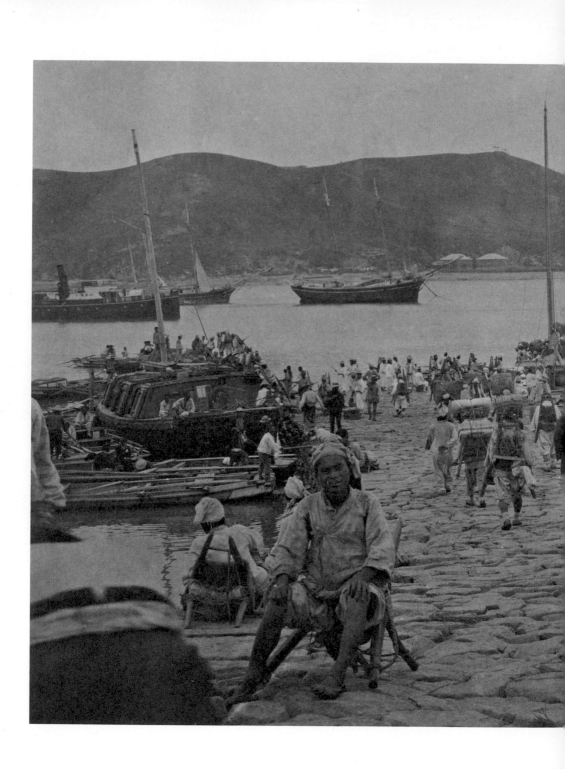

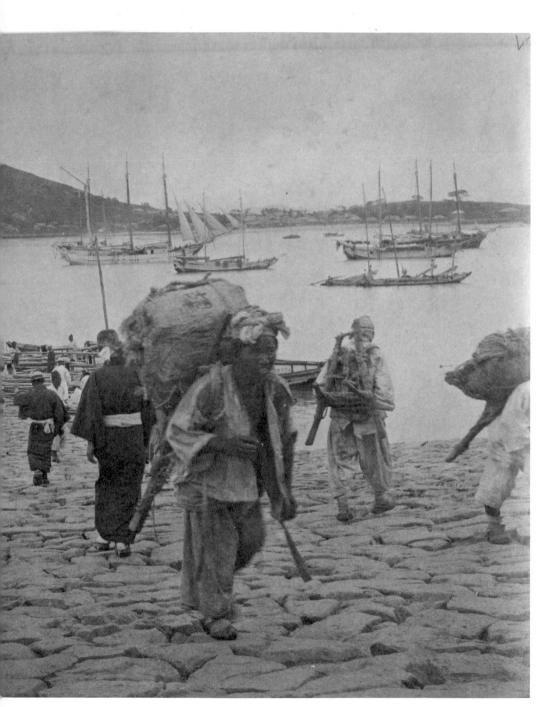

Antung Harbor, Manchuria, 1904

Manchurian barber, 1904

Korea, 1904

Female Korean villager carrying a heavy load of dishes on her head, 1904

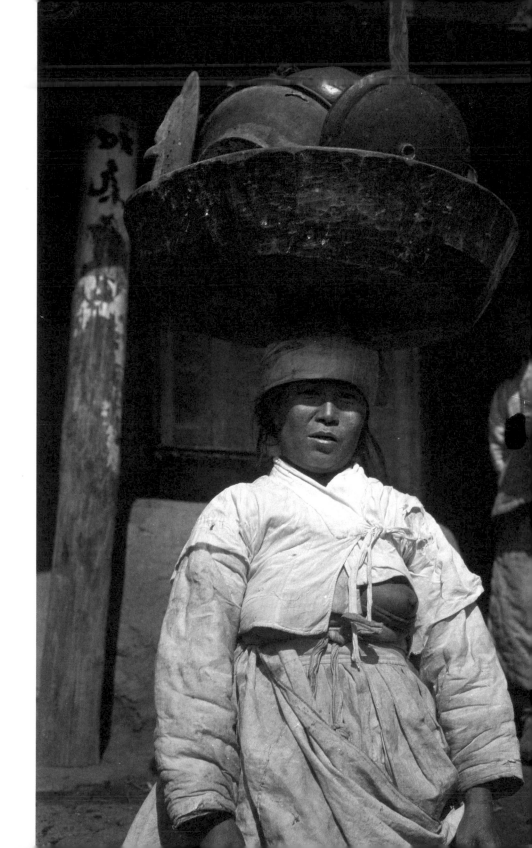

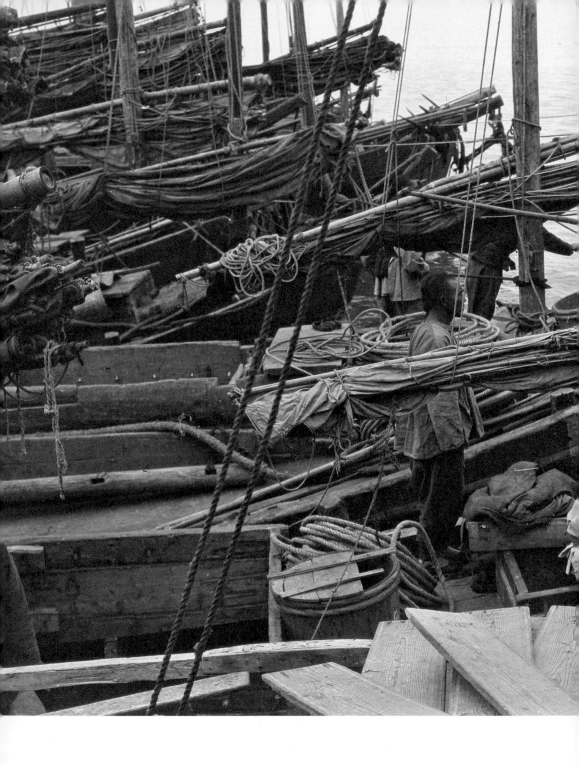

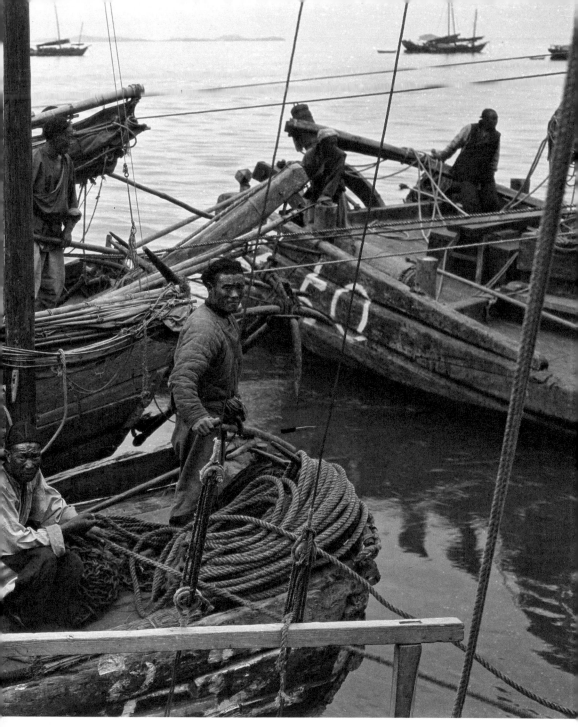

Antung Harbor, Manchuria, 1904

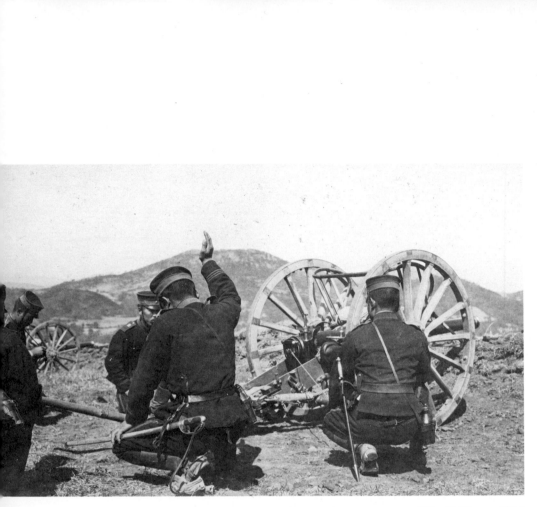

"Fire!". Korea, 1904

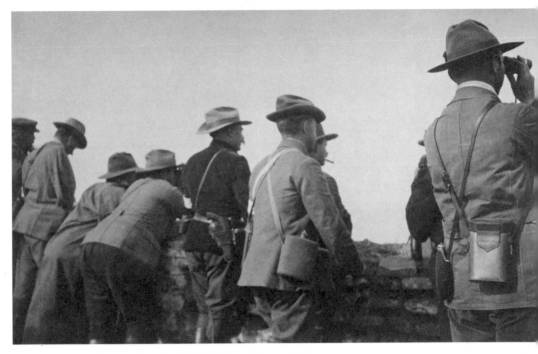

War Correspondents at Battle of Yalu River. Korea, 1904

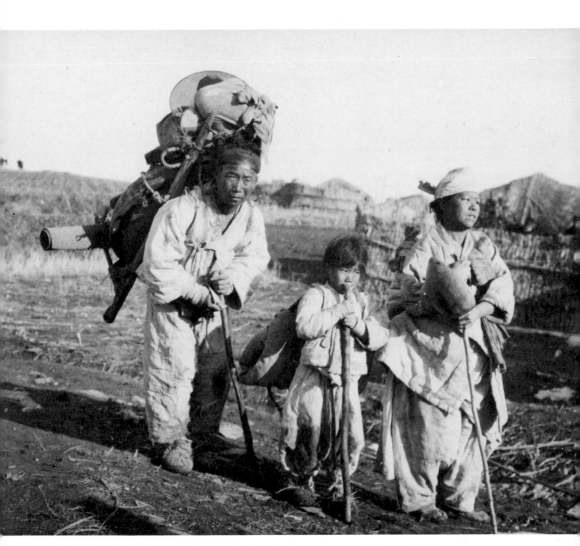

Small family of Korean refugees fleeing the Japanese army. Korea, 1904

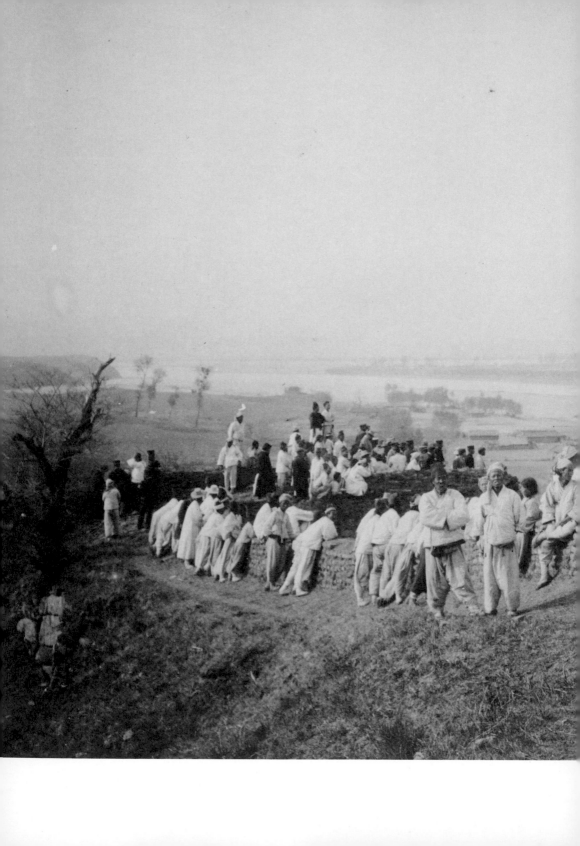

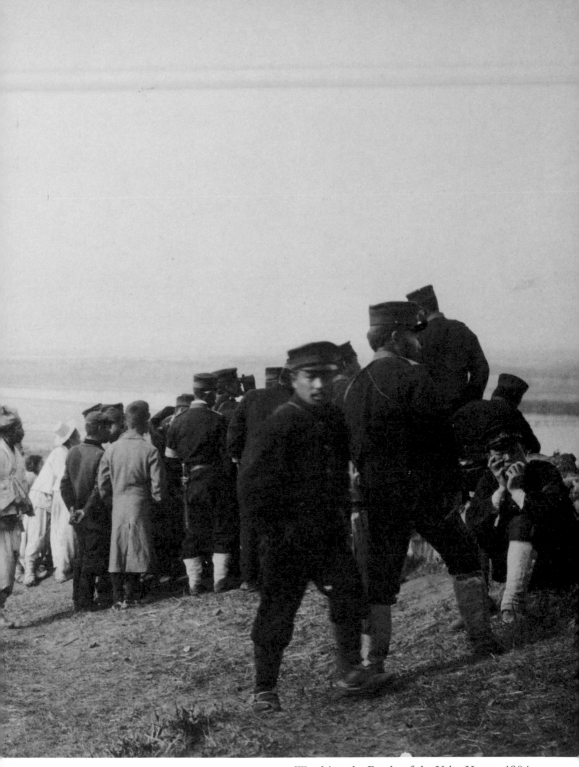

Watching the Battle of the Yalu. Korea, 1904

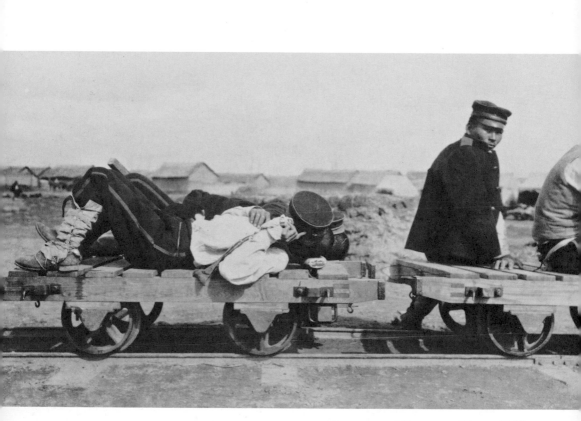

Japanese soldier at rest. Korea, 1904

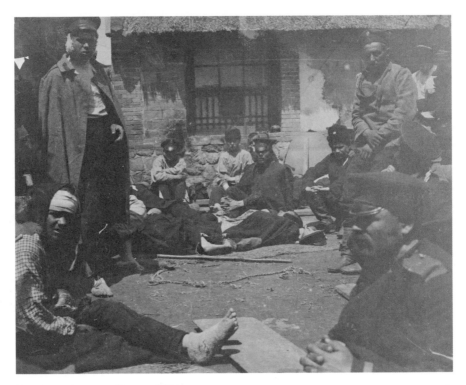

Russian prisoners. Korea, 1904

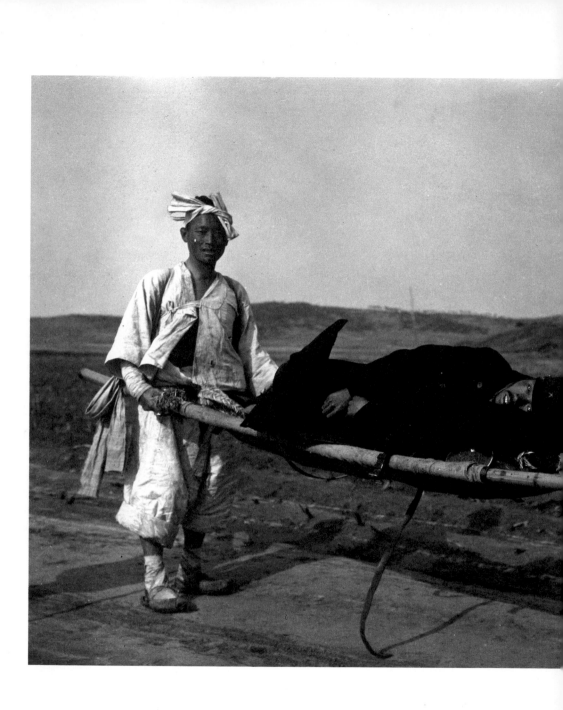

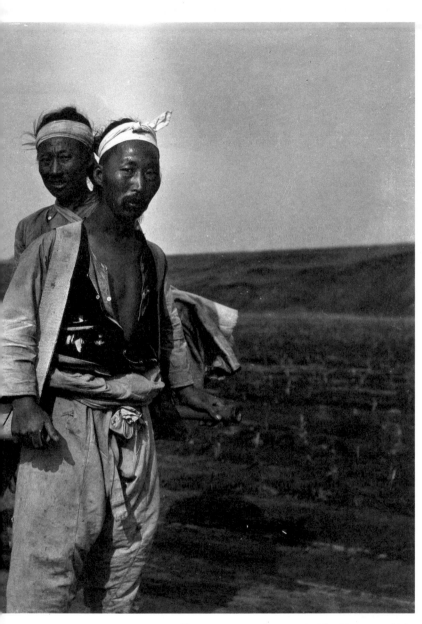

Japanese officer on a stretcher carried by Koreans, 1904

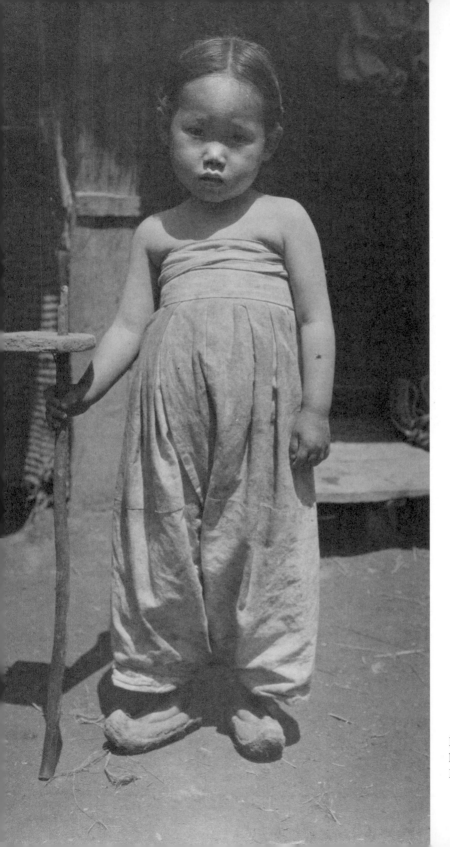

Korean kids made
homeless by war.
Korea, 1904

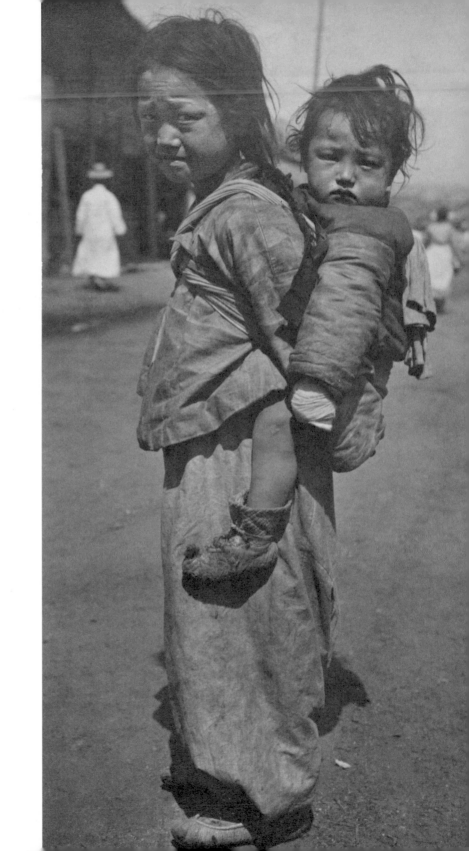

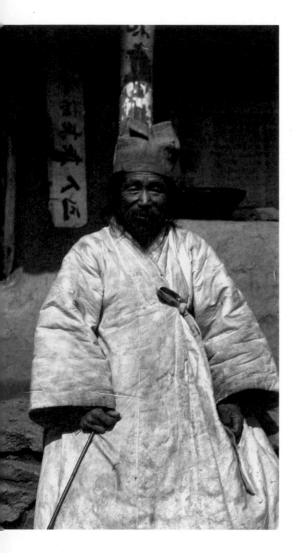
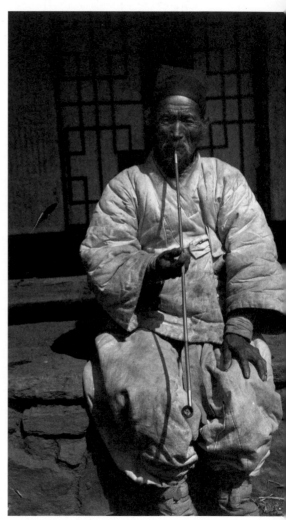

Portraits of elderly men. Korea, 1904

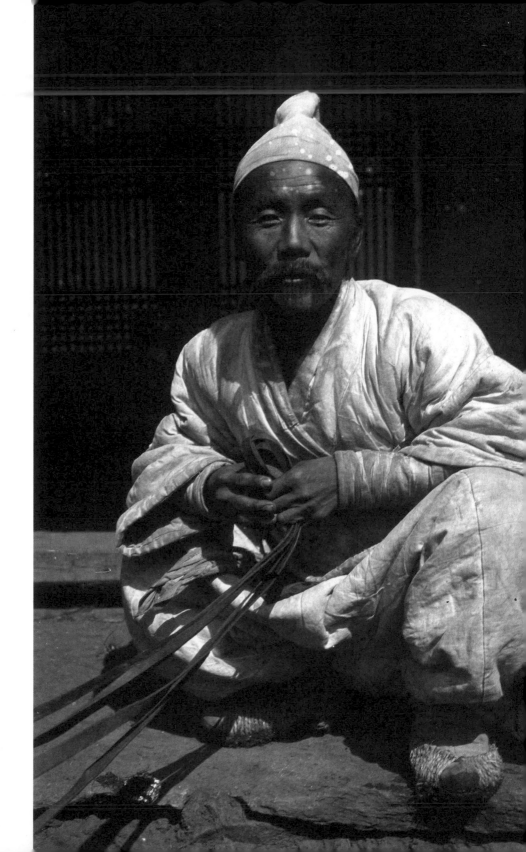

The San Francisco Earthquake, 1906

At 5.13 on the morning of 18 April 1906, San Francisco was shaken by a violent earthquake. The city would then be almost entirely destroyed by the fires that raged continuously over the next four days. There were thousands of casualties and the economic damage was enormous.

Jack and Charmian London's ranch in Sonoma Valley was situated only a few miles from the city. The couple hurried to San Francisco to get some idea of the damage. It was an enormous shock, so much so that, as Charmian later related, Jack declared that he would be unable to write a single word about the tragedy. "What use is trying? One can only put together a whole load of words and be frustrated at their futility."

In the end, he agreed to write an article for *Collier's* magazine, persuaded by his rapidly increasing debts caused by the construction of the *Snark* and his ranch.

The couple would thus return to San Francisco and the devastated areas surrounding it several times during the next few days and the following month. The writer would also take his camera onto those streets, and the images he took are among the greatest he ever produced. A devastated and almost deserted city unfolded before his eyes, but London did not surrender to the subtle charm of the ruins, endeavouring instead to compose a "state of things", bestowing on those locations a frontal and direct gaze, just as in his writing.

"The Story of an Eye-Witness" appeared in *Collier's* magazine on 5 May 1906.

Jack and Charmian London on the streets of San Francisco, 1905

The Story of an Eyewitness

May 5, 1906

Upon receipt of the first news of the earthquake, Colliers *telegraphed to Mr. Jack London—who lives only forty miles from San Francisco—requesting him to go to the scene of the disaster and write the story of what he saw. Mr. London started at once, and he sent the following dramatic description of the tragic events he witnessed in the burning city.*

The earthquake shook down in San Francisco hundreds of thousands of dollars worth of walls and chimneys. But the conflagration that followed burned up hundreds of millions of dollars' worth of property There is no estimating within hundreds of millions the actual damage wrought. Not in history has a modern imperial city been so completely destroyed. San Francisco is gone. Nothing remains of it but memories and a fringe of dwelling houses on its outskirts. Its industrial section is wiped out. Its business section is wiped out. Its social and residential section is wiped out. The factories and warehouses, the great stores and newspaper buildings, the hotels and the palaces of the nabobs, are all gone. Remains only the fringe of dwelling houses on the outskirts of what was once San Francisco.

Within an hour after the earthquake shock the smoke of San Francisco's burning was a lurid tower visible a hundred miles away. And for three days and nights this lurid tower swayed in the sky, reddening the sun, darkening the day, and filling the land with smoke.

On Wednesday morning at a quarter past five came the earthquake. A minute later the flames were leaping upward. In a dozen different quarters south of Market Street, in the working-class ghetto, and in the factories, fires started. There was no opposing the flames. There was no organization, no communication. All the cunning adjustments of a twentieth century city had been smashed by the earthquake. The streets were humped into ridges and depressions, and piled with the debris of fallen walls. The steel rails were twisted into perpendicular and horizontal angles. The telephone and telegraph systems were disrupted. And the great water-mains had burst. All the shrewd contrivances and safeguards of man had been thrown out of gear by thirty seconds' twitching of the earth-crust.

The Fire Made its Own Draft

By Wednesday afternoon, inside of twelve hours, half the heart of the city was gone. At that time I watched the vast conflagration from out on the bay. It was dead calm. Not a flicker of wind stirred. Yet from every side wind was pouring in upon the city. East, west, north, and south, strong winds were blowing upon the doomed city. The heated air rising made an enormous suck. Thus did the fire of itself build its own colossal chimney through the atmosphere. Day and night this dead calm continued, and yet, near to the flames, the wind was often half a gale, so mighty was the suck.

Wednesday night saw the destruction of the very heart of the city. Dynamite was lavishly used, and many of San Francisco proudest structures were crumbled by man himself into ruins, but there was no withstanding the onrush of the flames. Time and again successful stands were made by

the fire-fighters, and every time the flames flanked around on either side or came up from the rear, and turned to defeat the hard-won victory.

An enumeration of the buildings destroyed would be a directory of San Francisco. An enumeration of the buildings undestroyed would be a line and several addresses. An enumeration of the deeds of heroism would stock a library and bankrupt the Carnegie medal fund. An enumeration of the dead-will never be made. All vestiges of them were destroyed by the flames. The number of the victims of the earthquake will never be known. South of Market Street, where the loss of life was particularly heavy, was the first to catch fire.

Remarkable as it may seem, Wednesday night while the whole city crashed and roared into ruin, was a quiet night. There were no crowds. There was no shouting and yelling. There was no hysteria, no disorder. I passed Wednesday night in the path of the advancing flames, and in all those terrible hours I saw not one woman who wept, not one man who was excited, not one person who was in the slightest degree panic stricken.

Before the flames, throughout the night, fled tens of thousands of homeless ones. Some were wrapped in blankets. Others carried bundles of bedding and dear household treasures. Sometimes a whole family was harnessed to a carriage or delivery wagon that was weighted down with their possessions. Baby buggies, toy wagons, and go-carts were used as trucks, while every other person was dragging a trunk. Yet everybody was gracious. The most perfect courtesy obtained. Never in all San Francisco's history, were her people so kind and courteous as on this night of terror.

A Caravan of Trunks

All night these tens of thousands fled before the flames. Many of them, the poor people from the labor ghetto, had fled all day as well. They had left their homes burdened with possessions. Now and again they lightened up, flinging out upon the street clothing and treasures they had dragged for miles.

They held on longest to their trunks, and over these trunks many a strong man broke his heart that night. The hills of San Francisco are steep, and up these hills, mile after mile, were the trunks dragged. Everywhere were trunks with across them lying their exhausted owners, men and women. Before the march of the flames were flung picket lines of soldiers. And a block at a time, as the flames advanced, these pickets retreated. One of their tasks was to keep the trunk-pullers moving. The exhausted creatures, stirred on by the menace of bayonets, would arise and struggle up the steep pavements, pausing from weakness every five or ten feet.

Often, after surmounting a heart-breaking hill. they would find another wall of flame advancing upon them at right angles and be compelled to change anew the line of their retreat. In the end, completely played out, after toiling for a dozen hours like giants, thousands of them were compelled to abandon their trunks. Here the shopkeepers and soft members of the middle class were at a disadvantage. But the working-men dug holes in vacant lots and backyards and buried their trunks.

The Doomed City

At nine o'clock Wednesday evening I walked down through the very heart of the city. I walked through miles and miles of magnificent buildings and towering skyscrapers. Here was no

fire. All was in perfect order. The police patrolled the streets. Every building had its watchman at the door. And yet it was doomed, all of it. There was no water. The dynamite was giving out. And at right angles two different conflagrations were sweeping down upon it.

At one o'clock in the morning I walked down through the same section. Everything still stood intact. There was no fire. And yet there was a change. A rain of ashes was falling. The watchmen at the doors were gone. The police had been withdrawn. There were no firemen, no fire engines, no men fighting with dynamite. The district had been absolutely abandoned. I stood at the corner of Kearny and Market, in the very innermost heart of San Francisco. Kearny Street was deserted. Half a dozen blocks away it was burning on both sides. The street was a wall of flame. And against this wall of flame, silhouetted sharply, were two United States cavalrymen sitting their horses, calming watching. That was all. Not another person was in sight. In the intact heart of the city two troopers sat their horses and watched.

Spread of the Conflagration

Surrender was complete. There was no water. The sewers had long since been pumped dry. There was no dynamite. Another fire had broken out further uptown, and now from three sides conflagrations were sweeping down. The fourth side had been burned earlier in the day. In that direction stood the tottering walls of the Examiner building, the burned-out Call building, the smoldering ruins of the Grand Hotel, and the gutted, devastated, dynamited Palace Hotel

The following will illustrate the sweep of the flames and the inability of men to calculate their spread. At eight o'clock

Wednesday evening I passed through Union Square. It was packed with refugees. Thousands of them had gone to bed on the grass. Government tents had been set up, supper was being cooked, and the refugees were lining up for free meals

At half past one in the morning three sides of Union Square were in flames. The fourth side, where stood the great St. Francis Hotel was still holding out. An hour later, ignited from top and sides the St. Francis was flaming heavenward. Union Square, heaped high with mountains of trunks, was deserted. Troops, refugees, and all had retreated.

A Fortune for a Horse!

It was at Union Square that I saw a man offering a thousand dollars for a team of horses. He was in charge of a truck piled high with trunks from some hotel. It had been hauled here into what was considered safety, and the horses had been taken out. The flames were on three sides of the Square and there were no horses.

Also, at this time, standing beside the truck, I urged a man to seek safety in flight. He was all but hemmed in by several conflagrations. He was an old man and he was on crutches. Said he: "Today is my birthday. Last night I was worth thirty-thousand dollars. I bought five bottles of wine, some delicate fish and other things for my birthday dinner. I have had no dinner, and all I own are these crutches."

I convinced him of his danger and started him limping on his way. An hour later, from a distance, I saw the truck-load of trunks burning merrily in the middle of the street.

On Thursday morning at a quarter past five, just twenty-four hours after the earthquake, I sat on the steps of a small residence on Nob Hill. With me sat Japanese, Italians,

Chinese, and negroes—a bit of the cosmopolitan flotsam of the wreck of the city. All about were the palaces of the nabob pioneers of Forty-nine. To the east and south at right angles, were advancing two mighty walls of flame

I went inside with the owner of the house on the steps of which I sat. He was cool and cheerful and hospitable. "Yesterday morning," he said, "I was worth six hundred thousand dollars. This morning this house is all I have left. It will go in fifteen minutes. He pointed to a large cabinet. "That is my wife's collection of china. This rug upon which we stand is a present. It cost fifteen hundred dollars. Try that piano. Listen to its tone. There are few like it. There are no horses. The flames will be here in fifteen minutes."

Outside the old Mark Hopkins residence a palace was just catching fire. The troops were falling back and driving the refugees before them. From every side came the roaring of flames, the crashing of walls, and the detonations of dynamite

The Dawn of the Second Day

I passed out of the house. Day was trying to dawn through the smoke-pall. A sickly light was creeping over the face of things. Once only the sun broke through the smoke-pall, blood-red, and showing quarter its usual size. The smoke-pall itself, viewed from beneath, was a rose color that pulsed and fluttered with lavender shades Then it turned to mauve and yellow and dun. There was no sun. And so dawned the second day on stricken San Francisco.

An hour later I was creeping past the shattered dome of the City Hall. There was no better exhibit of the destructive force of the earthquake. Most of the stone had been shaken from the great dome, leaving standing the naked framework

of steel. Market Street was piled high with the wreckage, and across the wreckage lay the overthrown pillars of the City Hall shattered into short crosswise sections.

This section of the city with the exception of the Mint and the Post-Office, was already a waste of smoking ruins. Here and there through the smoke, creeping warily under the shadows of tottering walls, emerged occasional men and women. It was like the meeting of the handful of survivors after the day of the end of the world.

Beeves Slaughtered and Roasted

On Mission Street lay a dozen steers, in a neat row stretching across the street just as they had been struck down by the flying ruins of the earthquake. The fire had passed through afterward and roasted them. The human dead had been carried away before the fire came. At another place on Mission Street I saw a milk wagon. A steel telegraph pole had smashed down sheer through the driver's seat and crushed the front wheels. The milk cans lay scattered around.

All day Thursday and all Thursday night, all day Friday and Friday night, the flames still raged on.

Friday night saw the flames finally conquered though not until Russian Hill and Telegraph Hill had been swept and three-quarters of a mile of wharves and docks had been licked up.

The Last Stand

The great stand of the fire-fighters was made Thursday night on Van Ness Avenue. Had they failed here, the comparative-

ly few remaining houses of the city would have been swept. Here were the magnificent residences of the second generation of San Francisco nabobs, and these, in a solid zone, were dynamited down across the path of the fire. Here and there the flames leaped the zone, but these fires were beaten out, principally by the use of wet blankets and rugs.

San Francisco, at the present time, is like the crater of a volcano, around which are camped tens of thousands of refugees. At the Presidio alone are at least twenty thousand. All the surrounding cities and towns are jammed with the homeless ones, where they are being cared for by the relief committees. The refugees were carried free by the railroads to any point they wished to go, and it is estimated that over one hundred thousand people have left the peninsula on which San Francisco stood. The Government has the situation in hand, and, thanks to the immediate relief given by the whole United States, there is not the slightest possibility of a famine. The bankers and business men have already set about making preparations to rebuild San Francisco.

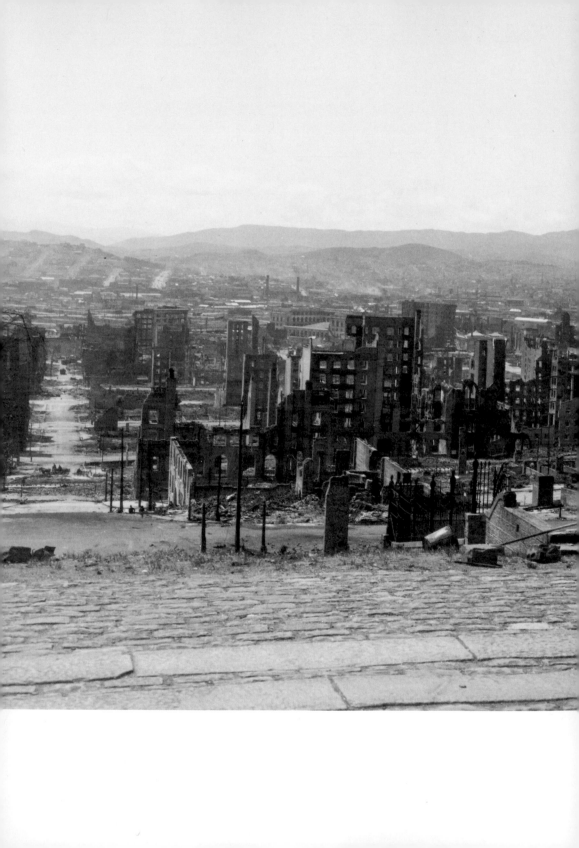

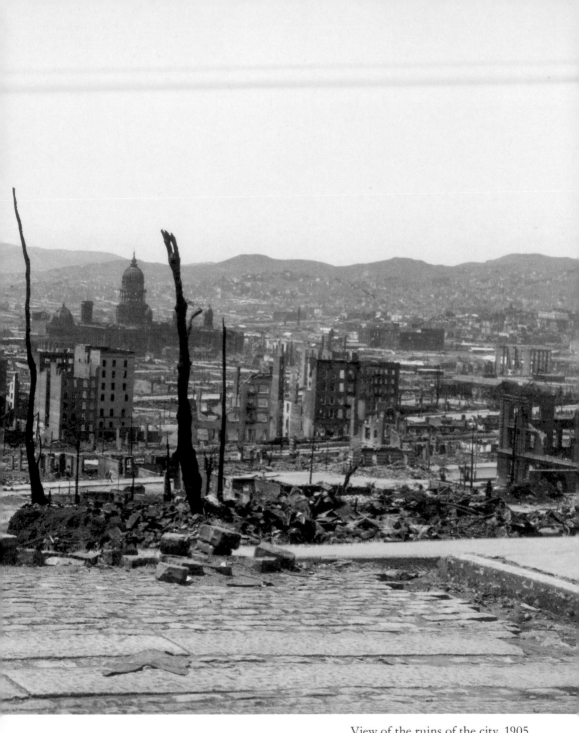

View of the ruins of the city, 1905

Ruins of the City Hall, 1906

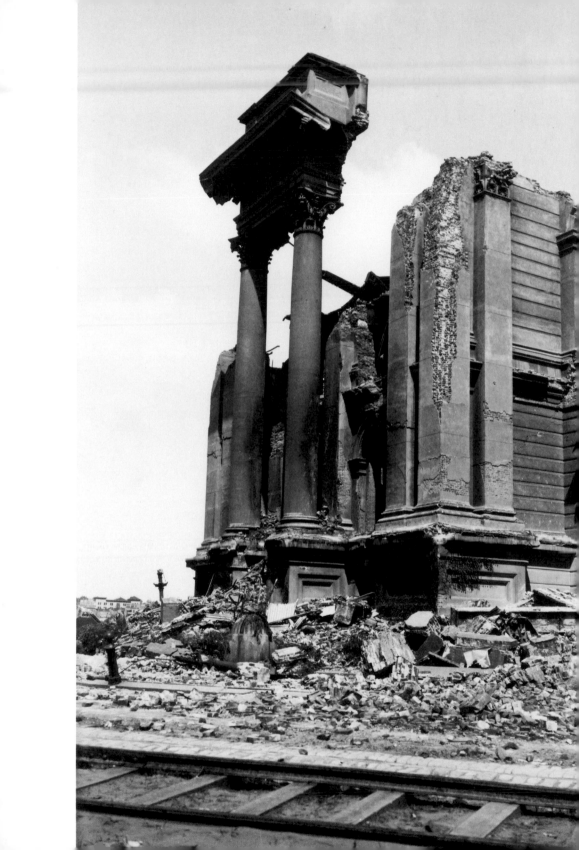

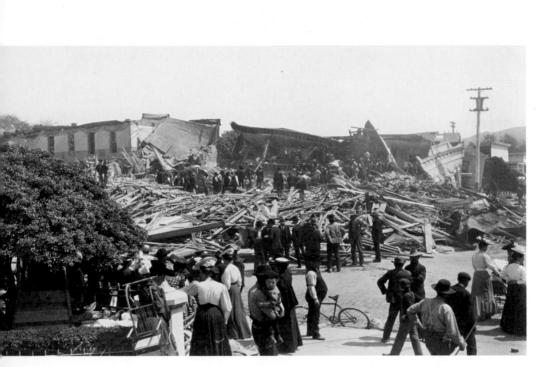

Assessing the damage, Santa Rosa, 1906

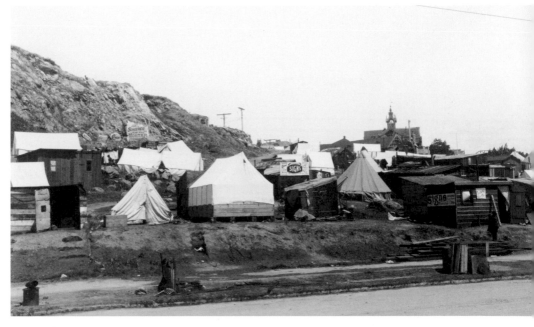

Market Street refugee camp, 1906

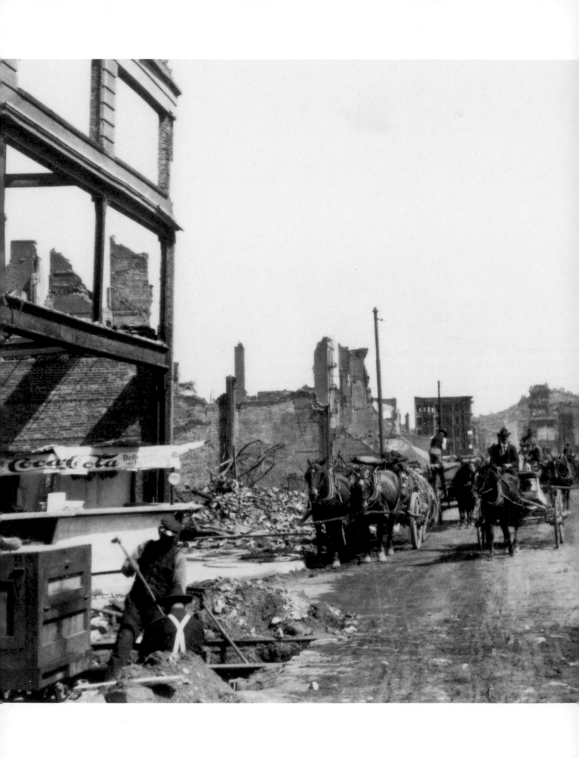

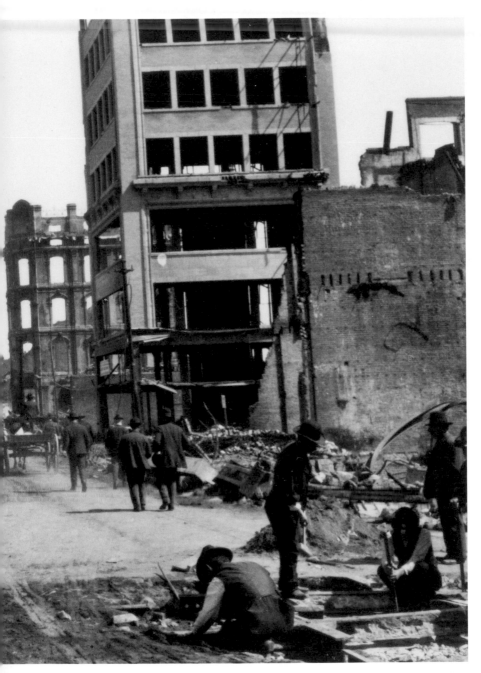

Kearny Street, 1906

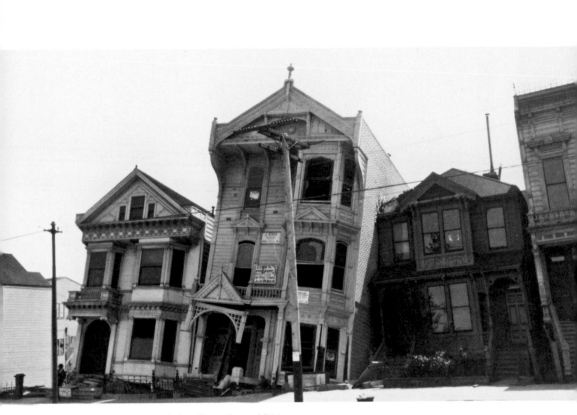

Apartments collapsed. San Francisco, 1906

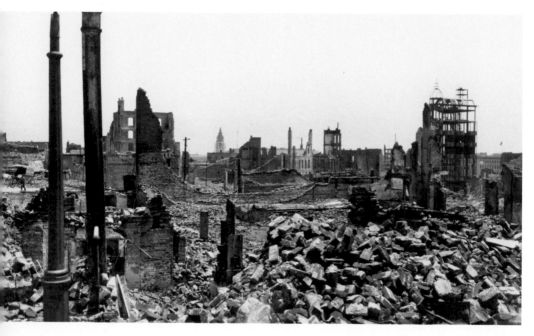

Ruins of the Barbary Coast, 1906

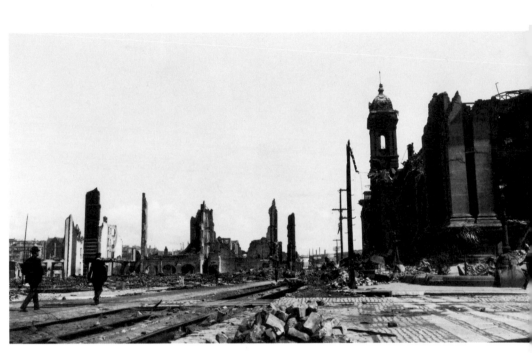

West side of the City Hall, 1906

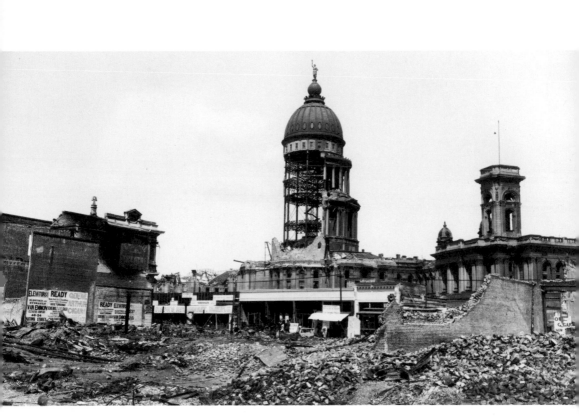

View of the City Hall, 1906

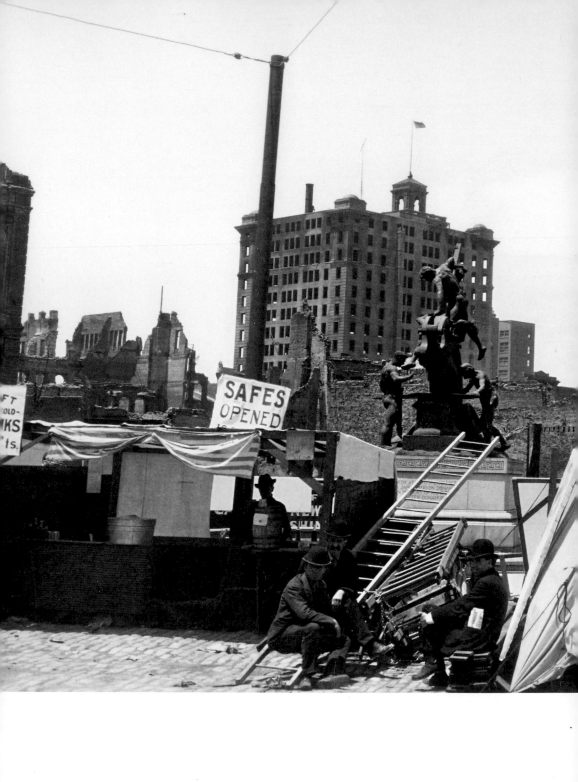

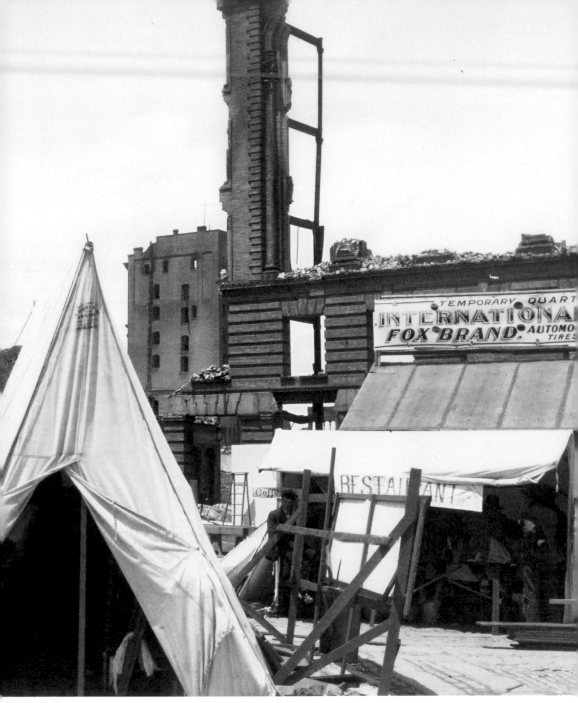

Market Street, 1906

Ruins of the San Francisco Stock Exchange, 1906

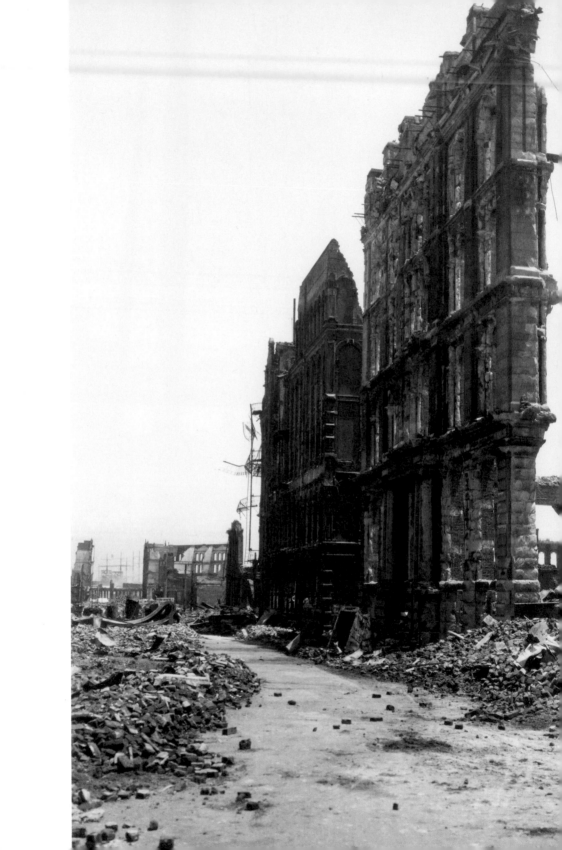

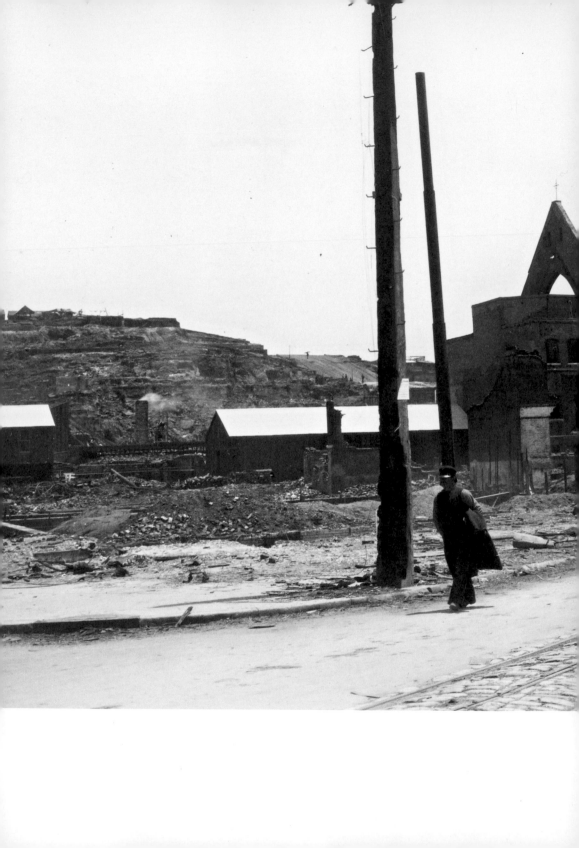

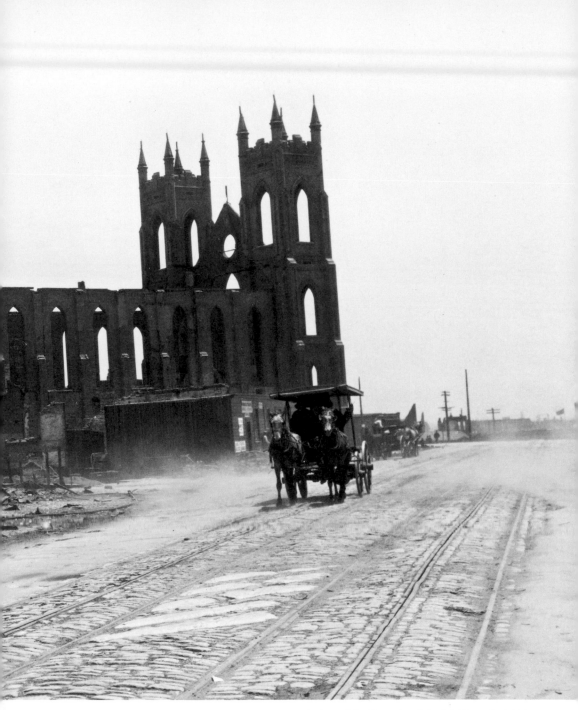

Ruins of St. Francis of Assisi Church, 1906

The Cruise of the Snark

In 1907, the dream of a lifetime became reality, the adventure of adventures: a trip around the world on a sailing boat. London had already ploughed many oceans, and his adventures on the seas had provided the inspiration for celebrated novels and short stories.

The writer had become an icon of American literature, his life almost as legendary as his writing. But comfort was too static a state for someone such as he, with a pressing urge to "see". Hence he threw himself into the design and construction of the *Snark*, a boat that was meant to take him, together with his wife Charmian, to the other side of the world on a voyage that was to last at least seven years.

The *Snark* set sail from San Francisco on 23 April 1907. On board were a small crew and all that was necessary so that Jack, between looking at one navigational map and another, might maintain his habit of writing at least a thousand words a day: the equipment included a typewriter, about 400 books, a phonograph and something like 500 records. But this was not all. Jack also took with him several cameras of various formats.

The *Snark* headed towards the South Seas, from Hawaii to the Marquesas Islands, Tahiti, Samoa, the Fiji Islands, as far as the Solomon Islands, where the voyage was prematurely interrupted when Jack succumbed to a rare tropical disease and was forced to hurry to Sydney to seek hospital treatment.

During this magnificent adventure at sea, the author took about 4,000 photos of a world that was then virtually unknown to his contemporaries. In this instance too, his gaze stands out for its direct, piercing style, free from the temptation to resort to any of the clichés typical of depictions of exotic cultures. Genuinely curious about human beings, Jack London portrayed the natives of these remote nations without lingering on the folkloristic aspect, but maintaining their individuality to the full, their dignity and mystery. In some cases, such as the Molokai lepers, his images and writing helped to disprove what he considered to be banal stereotypes dictated primarily through ignorance and fear.

The book *The Cruise of the Snark* was published in 1911, in an edition that also included some of his photographs, adding to the writer's limitless production a fascinating and hybrid work, at one and the same time a thrilling travel journal, an anthropological essay and a navigational treatise.

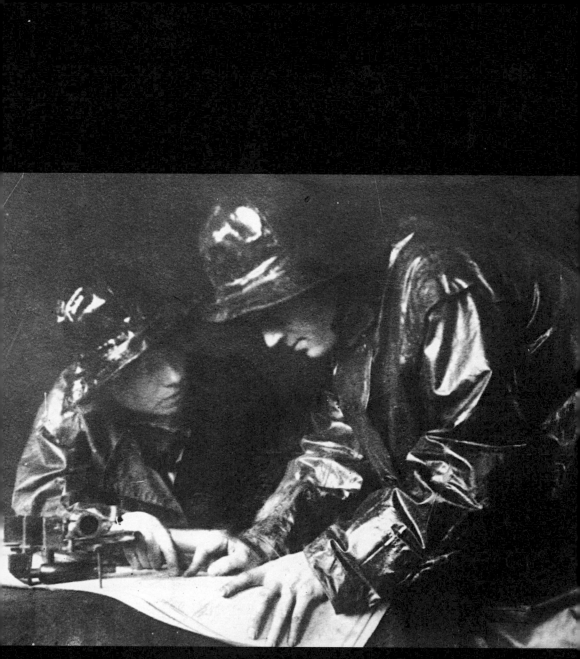

Jack and Charmian London, 1906

The Cruise of the Snark

"Yes have heard the beat of the offshore wind,
And the thresh of the deep-sea rain;
You have heard the song—how long! how long!
Pull out on the trail again!"

Rudyard Kipling

To CHARMIAN
The mate of the "snark"
who took the wheel, night or day,
when entering
or leaving port or running a passage,
who took the wheel in every emergency, and
who wept
after two years of sailing, when the
voyage was discontinued

Chapter I

Foreword

It began in the swimming pool at Glen Ellen. Between swims it was our wont to come out and lie in the sand and let our skins breathe the warm air and soak in the sunshine. Roscoe was a yachtsman. I had followed the sea a bit. It was inevitable that we should talk about boats. We talked about small boats, and the seaworthiness of small boats. We instanced Captain Slocum and his three years' voyage around the world in the *Spray*.

We asserted that we were not afraid to go around the world in a small boat, say forty feet long. We asserted furthermore

that we would like to do it. We asserted finally that there was nothing in this world we'd like better than a chance to do it.

"Let us do it," we said... in fun.

Then I asked Charmian privily if she'd really care to do it, and she said that it was too good to be true.

The next time we breathed our skins in the sand by the swimming pool I said to Roscoe, "Let us do it."

I was in earnest, and so was he, for he said:

"When shall we start?"

I had a house to build on the ranch, also an orchard, a vineyard, and several hedges to plant, and a number of other things to do. We thought we would start in four or five years. Then the lure of the adventure began to grip us. Why not start at once? We'd never be younger, any of us. Let the orchard, vineyard, and hedges be growing up while we were away. When we came back, they would be ready for us, and we could live in the barn while we built the house.

So the trip was decided upon, and the building of the *Snark* began. We named her the *Snark* because we could not think of any other name—this information is given for the benefit of those who otherwise might think there is something occult in the name.

Our friends cannot understand why we make this voyage. They shudder, and moan, and raise their hands. No amount of explanation can make them comprehend that we are moving along the line of least resistance; that it is easier for us to go down to the sea in a small ship than to remain on dry land, just as it is easier for them to remain on dry land than to go down to the sea in the small ship. This state of mind comes of an undue prominence of the ego. They cannot get away from themselves. They cannot come out of themselves long enough to see that their line of least resistance is not necessarily everybody else's line of least resistance. They make of their own bundle of de-

sires, likes, and dislikes a yardstick wherewith to measure the desires, likes, and dislikes of all creatures. This is unfair. I tell them so. But they cannot get away from their own miserable egos long enough to hear me. They think I am crazy. In return, I am sympathetic. It is a state of mind familiar to me. We are all prone to think there is something wrong with the mental processes of the man who disagrees with us.

The ultimate word is I LIKE. It lies beneath philosophy, and is twined about the heart of life. When philosophy has maundered ponderously for a month, telling the individual what he must do, the individual says, in an instant, "I LIKE," and does something else, and philosophy goes glimmering. It is I LIKE that makes the drunkard drink and the martyr wear a hair shirt; that makes one man a reveller and another man an anchorite; that makes one man pursue fame, another gold, another love, and another God. Philosophy is very often a man's way of explaining his own I LIKE.

But to return to the *Snark*, and why I, for one, want to journey in her around the world. The things I like constitute my set of values. The thing I like most of all is personal achievement—not achievement for the world's applause, but achievement for my own delight. It is the old "I did it! I did it! With my own hands I did it!" But personal achievement, with me, must be concrete. I'd rather win a water-fight in the swimming pool, or remain astride a horse that is trying to get out from under me, than write the great American novel. Each man to his liking. Some other fellow would prefer writing the great American novel to winning the water-fight or mastering the horse.

Possibly the proudest achievement of my life, my moment of highest living, occurred when I was seventeen. I was in a three-masted schooner off the coast of Japan. We were in a typhoon. All hands had been on deck most of the night. I was called from my bunk at seven in the morning to take

the wheel. Not a stitch of canvas was set. We were running before it under bare poles, yet the schooner fairly tore along. The seas were all of an eighth of a mile apart, and the wind snatched the whitecaps from their summits, filling. The air so thick with driving spray that it was impossible to see more than two waves at a time. The schooner was almost unmanageable, rolling her rail under to starboard and to port, veering and yawing anywhere between south-east and south-west, and threatening, when the huge seas lifted under her quarter, to broach to. Had she broached to, she would ultimately have been reported lost with all hands and no tidings.

I took the wheel. The sailing-master watched me for a space. He was afraid of my youth, feared that I lacked the strength and the nerve. But when he saw me successfully wrestle the schooner through several bouts, he went below to breakfast. Fore and aft, all hands were below at breakfast. Had she broached to, not one of them would ever have reached the deck. For forty minutes I stood there alone at the wheel, in my grasp the wildly careering schooner and the lives of twenty-two men. Once we were pooped. I saw it coming, and, half-drowned, with tons of water crushing me, I checked the schooner's rush to broach to. At the end of the hour, sweating and played out, I was relieved. But I had done it! With my own hands I had done my trick at the wheel and guided a hundred tons of wood and iron through a few million tons of wind and waves.

My delight was in that I had done it—not in the fact that twenty-two men knew I had done it. Within the year over half of them were dead and gone, yet my pride in the thing performed was not diminished by half. I am willing to confess, however, that I do like a small audience. But it must be a very small audience, composed of those who love me and whom I love. When I then accomplish personal achievement, I have a

feeling that I am justifying their love for me. But this is quite apart from the delight of the achievement itself. This delight is peculiarly my own and does not depend upon witnesses. When I have done some such thing, I am exalted. I glow all over. I am aware of a pride in myself that is mine, and mine alone. It is organic. Every fibre of me is thrilling with it. It is very natural. It is a mere matter of satisfaction at adjustment to environment. It is success.

Life that lives is life successful, and success is the breath of its nostrils. The achievement of a difficult feat is successful adjustment to a sternly exacting environment. The more difficult the feat, the greater the satisfaction at its accomplishment. Thus it is with the man who leaps forward from the springboard, out over the swimming pool, and with a backward half-revolution of the body, enters the water head first. Once he leaves the springboard his environment becomes immediately savage, and savage the penalty it will exact should he fail and strike the water flat. Of course, the man does not have to run the risk of the penalty. He could remain on the bank in a sweet and placid environment of summer air, sunshine, and stability. Only he is not made that way. In that swift mid-air moment he lives as he could never live on the bank.

As for myself, I'd rather be that man than the fellows who sit on the bank and watch him. That is why I am building the *Snark*. I am so made. I like, that is all. The trip around the world means big moments of living. Bear with me a moment and look at it. Here am I, a little animal called a man—a bit of vitalized matter, one hundred and sixty-five pounds of meat and blood, nerve, sinew, bones, and brain,—all of it soft and tender, susceptible to hurt, fallible, and frail. I strike a light back-handed blow on the nose of an obstreperous horse, and a bone in my hand is broken. I put my head under the water for five minutes, and I am drowned. I fall twenty feet through

the air, and I am smashed. I am a creature of temperature. A few degrees one way, and my fingers and ears and toes blacken and drop off. A few degrees the other way, and my skin blisters and shrivels away from the raw, quivering flesh. A few additional degrees either way, and the life and the light in me go out. A drop of poison injected into my body from a snake, and I cease to move—for ever I cease to move. A splinter of lead from a rifle enters my head, and I am wrapped around in the eternal blackness.

Fallible and frail, a bit of pulsating, jelly-like life—it is all I am. About me are the great natural forces—colossal menaces, Titans of destruction, unsentimental monsters that have less concern for me than I have for the grain of sand I crush under my foot. They have no concern at all for me. They do not know me. They are unconscious, unmerciful, and unmoral. They are the cyclones and tornadoes, lightning flashes and cloud-bursts, tide-rips and tidal waves, undertows and waterspouts, great whirls and sucks and eddies, earthquakes and volcanoes, surfs that thunder on rock-ribbed coasts and seas that leap aboard the largest crafts that float, crushing humans to pulp or licking them off into the sea and to death—and these insensate monsters do not know that tiny sensitive creature, all nerves and weaknesses, whom men call Jack London, and who himself thinks he is all right and quite a superior being.

In the maze and chaos of the conflict of these vast and draughty Titans, it is for me to thread my precarious way. The bit of life that is I will exult over them. The bit of life that is I, in so far as it succeeds in baffling them or in bitting them to its service, will imagine that it is godlike. It is good to ride the tempest and feel godlike. I dare to assert that for a finite speck of pulsating jelly to feel godlike is a far more glorious feeling than for a god to feel godlike.

Here is the sea, the wind, and the wave. Here are the seas, the winds, and the waves of all the world. Here is ferocious environment. And here is difficult adjustment, the achievement of which is delight to the small quivering vanity that is I. I like. I am so made. It is my own particular form of vanity, that is all.

There is also another side to the voyage of the *Snark*. Being alive, I want to see, and all the world is a bigger thing to see than one small town or valley. We have done little outlining of the voyage. Only one thing is definite, and that is that our first port of call will be Honolulu. Beyond a few general ideas, we have no thought of our next port after Hawaii. We shall make up our minds as we get nearer, in a general way we know that we shall wander through the South Seas, take in Samoa, New Zealand, Tasmania, Australia, New Guinea, Borneo, and Sumatra, and go on up through the Philippines to Japan. Then will come Korea, China, India, the Red Sea, and the Mediterranean. After that the voyage becomes too vague to describe, though we know a number of things we shall surely do, and we expect to spend from one to several months in every country in Europe.

The *Snark* is to be sailed. There will be a gasolene engine on board, but it will be used only in case of emergency, such as in bad water among reefs and shoals, where a sudden calm in a swift current leaves a sailing-boat helpless. The rig of the *Snark* is to be what is called the "ketch." The ketch rig is a compromise between the yawl and the schooner. Of late years the yawl rig has proved the best for cruising. The ketch retains the cruising virtues of the yawl, and in addition manages to embrace a few of the sailing virtues of the schooner. The foregoing must be taken with a pinch of salt. It is all theory in my head. I've never sailed a ketch, nor even seen one. The theory commends itself to me. Wait till I get out on

the ocean, then I'll be able to tell more about the cruising and sailing qualities of the ketch.

As originally planned, the *Snark* was to be forty feet long on the water-line. But we discovered there was no space for a bath-room, and for that reason we have increased her length to forty-five feet. Her greatest beam is fifteen feet. She has no house and no hold. There is six feet of headroom, and the deck is unbroken save for two companionways and a hatch for'ard. The fact that there is no house to break the strength of the deck will make us feel safer in case great seas thunder their tons of water down on board. A large and roomy cockpit, sunk beneath the deck, with high rail and self-bailing, will make our rough-weather days and nights more comfortable.

There will be no crew. Or, rather, Charmian, Roscoe, and I are the crew. We are going to do the thing with our own hands. With our own hands we're going to circumnavigate the globe. Sail her or sink her, with our own hands we'll do it. Of course there will be a cook and a cabin-boy. Why should we stew over a stove, wash dishes, and set the table? We could stay on land if we wanted to do those things. Besides, we've got to stand watch and work the ship. And also, I've got to work at my trade of writing in order to feed us and to get new sails and tackle and keep the *Snark* in efficient working order. And then there's the ranch; I've got to keep the vineyard, orchard, and hedges growing.

When we increased the length of the *Snark* in order to get space for a bath-room, we found that all the space was not required by the bath-room. Because of this, we increased the size of the engine. Seventy horse-power our engine is, and since we expect it to drive us along at a nine-knot clip, we do not know the name of a river with a current swift enough to defy us.

We expect to do a lot of inland work. The smallness of the *Snark* makes this possible. When we enter the land, out go the

masts and on goes the engine. There are the canals of China, and the Yang-tse River. We shall spend months on them if we can get permission from the government. That will be the one obstacle to our inland voyaging—governmental permission. But if we can get that permission, there is scarcely a limit to the inland voyaging we can do.

When we come to the Nile, why we can go up the Nile. We can go up the Danube to Vienna, up the Thames to London, and we can go up the Seine to Paris and moor opposite the Latin Quarter with a bow-line out to Notre Dame and a stern-line fast to the Morgue. We can leave the Mediterranean and go up the Rhône to Lyons, there enter the Saône, cross from the Saône to the Maine through the Canal de Bourgogne, and from the Marne enter the Seine and go out the Seine at Havre. When we cross the Atlantic to the United States, we can go up the Hudson, pass through the Erie Canal, cross the Great Lakes, leave Lake Michigan at Chicago, gain the Mississippi by way of the Illinois River and the connecting canal, and go down the Mississippi to the Gulf of Mexico. And then there are the great rivers of South America. We'll know something about geography when we get back to California.

People that build houses are often sore perplexed; but if they enjoy the strain of it, I'll advise them to build a boat like the *Snark*. Just consider, for a moment, the strain of detail. Take the engine. What is the best kind of engine—the two cycle? three cycle? four cycle? My lips are mutilated with all kinds of strange jargon, my mind is mutilated with still stranger ideas and is foot-sore and weary from travelling in new and rocky realms of thought.—Ignition methods; shall it be make-and-break or jump-spark? Shall dry cells or storage batteries be used? A storage battery commends itself, but it requires a dynamo. How powerful a dynamo? And when we have installed a dynamo and a storage battery, it is simply

ridiculous not to light the boat with electricity. Then comes the discussion of how many lights and how many candle-power. It is a splendid idea. But electric lights will demand a more powerful storage battery, which, in turn, demands a more powerful dynamo.

And now that we've gone in for it, why not have a search-light? It would be tremendously useful. But the searchlight needs so much electricity that when it runs it will put all the other lights out of commission. Again we travel the weary road in the quest after more power for storage battery and dynamo. And then, when it is finally solved, some one asks, "What if the engine breaks down?" And we collapse. There are the sidelights, the binnacle light, and the anchor light. Our very lives depend upon them. So we have to fit the boat throughout with oil lamps as well.

But we are not done with that engine yet. The engine is powerful. We are two small men and a small woman. It will break our hearts and our backs to hoist anchor by hand. Let the engine do it. And then comes the problem of how to convey power for'ard from the engine to the winch. And by the time all this is settled, we redistribute the allotments of space to the engine-room, galley, bath-room, state-rooms, and cabin, and begin all over again. And when we have shifted the engine, I send off a telegram of gibberish to its makers at New York, something like this: *Toggle-joint abandoned change thrust-bearing accordingly distance from forward side of flywheel to face of stern post sixteen feet six inches.*

Just potter around in quest of the best steering gear, or try to decide whether you will set up your rigging with old-fashioned lanyards or with turnbuckles, if you want strain of detail. Shall the binnacle be located in front of the wheel in the centre of the beam, or shall it be located to one side in front of the wheel?—there's room right there for a library of sea-dog

controversy. Then there's the problem of gasolene, fifteen hundred gallons of it—what are the safest ways to tank it and pipe it? and which is the best fire-extinguisher for a gasolene fire? Then there is the pretty problem of the life-boat and the stowage of the same. And when that is finished, come the cook and cabin-boy to confront one with nightmare possibilities. It is a small boat, and we'll be packed close together. The servant-girl problem of landsmen pales to insignificance. We did select one cabin-boy, and by that much were our troubles eased. And then the cabin-boy fell in love and resigned.

And in the meanwhile how is a fellow to find time to study navigation—when he is divided between these problems and the earning of the money wherewith to settle the problems? Neither Roscoe nor I know anything about navigation, and the summer is gone, and we are about to start, and the problems are thicker than ever, and the treasury is stuffed with emptiness. Well, anyway, it takes years to learn seamanship, and both of us are seamen. If we don't find the time, we'll lay in the books and instruments and teach ourselves navigation on the ocean between San Francisco and Hawaii.

There is one unfortunate and perplexing phase of the voyage of the *Snark*. Roscoe, who is to be my co-navigator, is a follower of one, Cyrus R. Teed. Now Cyrus R. Teed has a different cosmology from the one generally accepted, and Roscoe shares his views. Wherefore Roscoe believes that the surface of the earth is concave and that we live on the inside of a hollow sphere. Thus, though we shall sail on the one boat, the *Snark*, Roscoe will journey around the world on the inside, while I shall journey around on the outside. But of this, more anon. We threaten to be of the one mind before the voyage is completed. I am confident that I shall convert him into making the journey on the outside, while he is equally confident that before we arrive back in San Francisco I shall be on the

inside of the earth. How he is going to get me through the crust I don't know, but Roscoe is ay a masterful man.

P.S.—That engine! While we've got it, and the dynamo, and the storage battery, why not have an ice-machine? Ice in the tropics! It is more necessary than bread. Here goes for the ice-machine! Now I am plunged into chemistry, and my lips hurt, and my mind hurts, and how am I ever to find the time to study navigation?

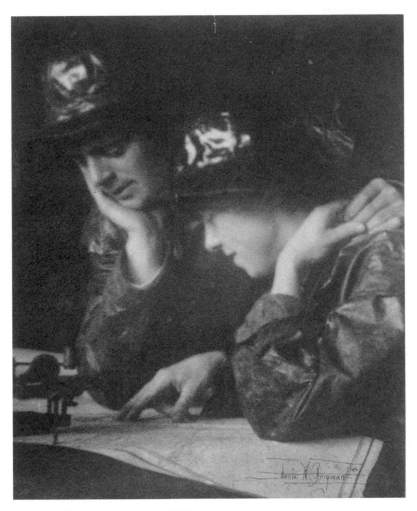

Jack and Charmian London, 1906

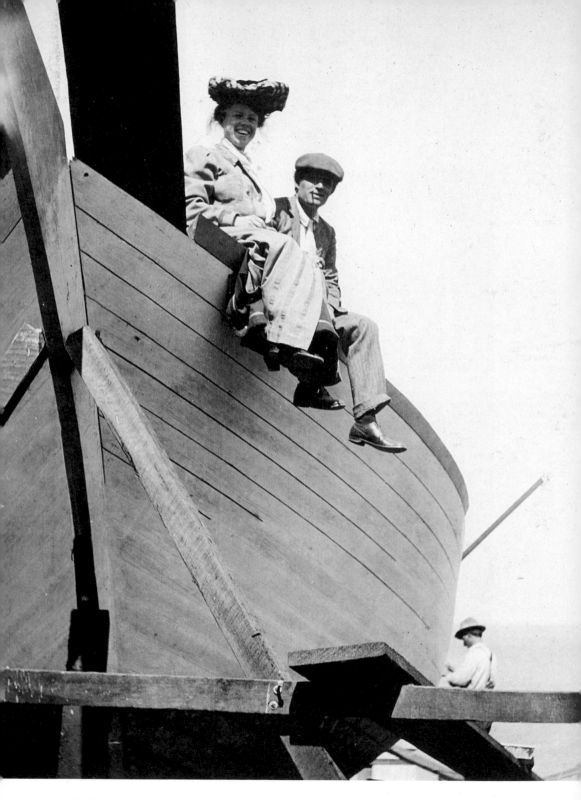

Jack and Charmian London visiting the Snark while it is under construction. San Francisco, 1906

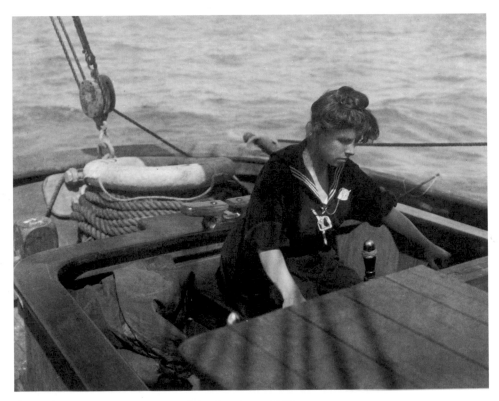

Charmian London at the helm of the Snark, ca. 1907

Leper band at a Fourth of July Parade.
Molokai, Hawaii, 1907

Netx pages: The pali (cliff) trail,
Molokai, Hawaii, 1907

[…] the horrors of Molokai, as they have been painted in
the past, do not exist. The Settlement has been written up
repeatedly by sensationalists, and usually by sensationalists
who have never laid eyes on it. Of course, leprosy is leprosy,
and it is a terrible thing; but so much that is lurid has been
written about Molokai that neither the lepers, nor those who

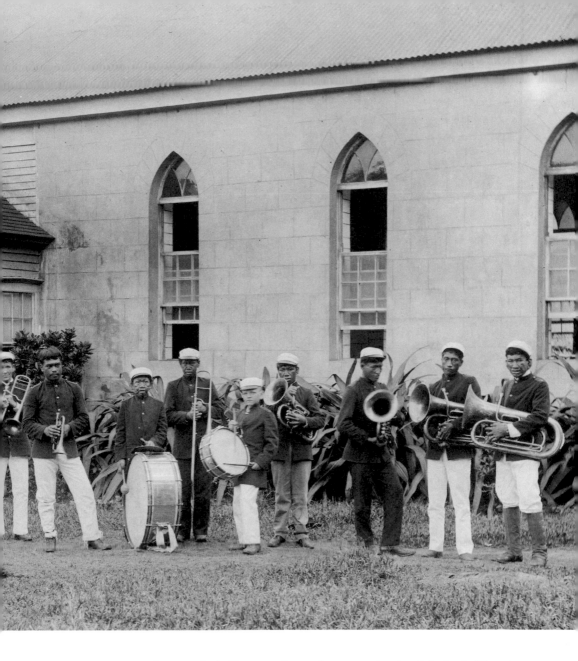

devote their lives to them, have received a fair deal. Here is a case in point. A newspaper writer, who, of course, had never been near the Settlement, vividly described Superintendent McVeigh, crouching in a grass hut and being besieged nightly by starving lepers on their knees, wailing for food. This hair-raising account was copied by the press all over the United

States and was the cause of many indignant and protesting editorials. Well, I lived and slept for five days in Mr. McVeigh's "grass hut" (which was a comfortable wooden cottage, by the way; and there isn't a grass house in the whole Settlement), and I heard the lepers wailing for food—only the wailing was peculiarly harmonious and rhythmic, and it was accompanied by the music of stringed instruments, violins, guitars, *ukuleles*, and banjos. Also, the wailing was of various sorts. The leper brass band wailed, and two singing societies wailed, and lastly a quintet of excellent voices wailed. So much for a lie that should never have been printed. The wailing was the serenade which the glee clubs always give Mr. McVeigh when he returns from a trip to Honolulu.

Leprosy is not so contagious as is imagined. I went for a week's visit to the Settlement, and I took my wife along—all of which would not have happened had we had any apprehen-

sion of contracting the disease. Nor did we wear long, gauntleted gloves and keep apart from the lepers. On the contrary, we mingled freely with them, and before we left, knew scores of them by sight and name. The precautions of simple cleanliness seem to be all that is necessary. On returning to their own houses, after having been among and handling lepers, the non-lepers, such as the physicians and the superintendent, merely wash their faces and hands with mildly antiseptic soap and change their coats.

That a leper is unclean, however, should be insisted upon; and the segregation of lepers, from what little is known of the disease, should be rigidly maintained. On the other hand, the awful horror with which the leper has been regarded in the past, and the frightful treatment he has received, have been unnecessary and cruel. […]

Chapter VII – *The Lepers of Molokai*

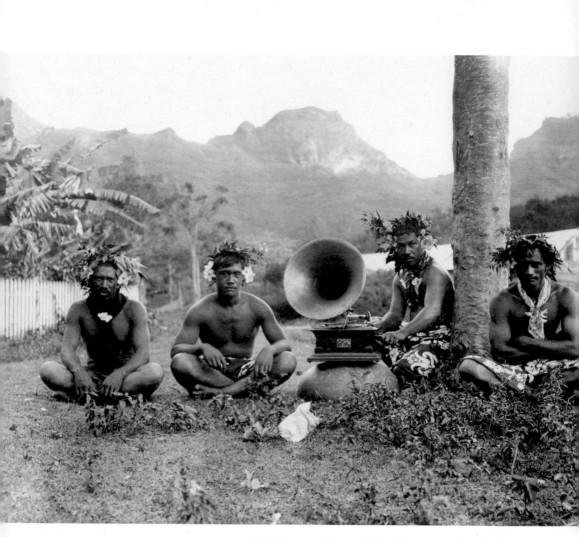

Inhabitants of Nuku Hiva, Marquesas Islands, 1907

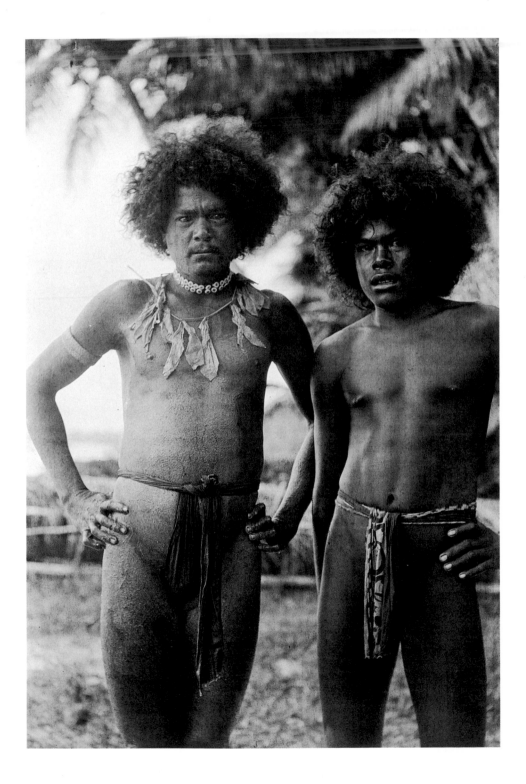

[...] A pure Marquesan is a rarity. They seem to be all half-breeds and strange conglomerations of dozens of different races. Nineteen able labourers are all the trader at Taiohae can muster for the loading of copra on shipboard, and in their veins runs the blood of English, American, Dane, German, French, Corsican, Spanish, Portuguese, Chinese, Hawaiian, Paumotan, Tahitian, and Easter Islander. There are more races than there are persons, but it is a wreckage of races at best. Life faints and stumbles and gasps itself away. In this warm, equable clime—a truly terrestrial paradise—where are never extremes of temperature and where the air is like balm, kept ever pure by the ozone-laden southeast trade, asthma, phthisis, and tuberculosis flourish as luxuriantly as the vegetation. Everywhere, from the few grass huts, arises the racking cough or exhausted groan of wasted lungs. Other horrible diseases prosper as well, but the most deadly of all are those that attack the lungs. There is a form of consumption called "galloping," which is especially dreaded. In two months' time it reduces the strongest man to a skeleton under a grave-cloth. In valley after valley the last inhabitant has passed and the fertile soil has relapsed to jungle. In Melville's day the valley of Hapaa (spelled by him "Happar") was peopled by a strong and warlike tribe. A generation later, it contained but two hundred persons. To-day it is an untenanted, howling, tropical wilderness.

We climbed higher and higher in the valley, our unshod stallions picking their steps on the disintegrating trail, which led in and out through the abandoned *pae-paes* and insatiable jungle. The sight of red mountain apples, the *ohias*, familiar to us from Hawaii, caused a native to be sent climbing after them. And again he climbed for cocoa-nuts. I have drunk the cocoanuts of Jamaica and of Hawaii, but I never knew how delicious such draught could be till I drank it here in

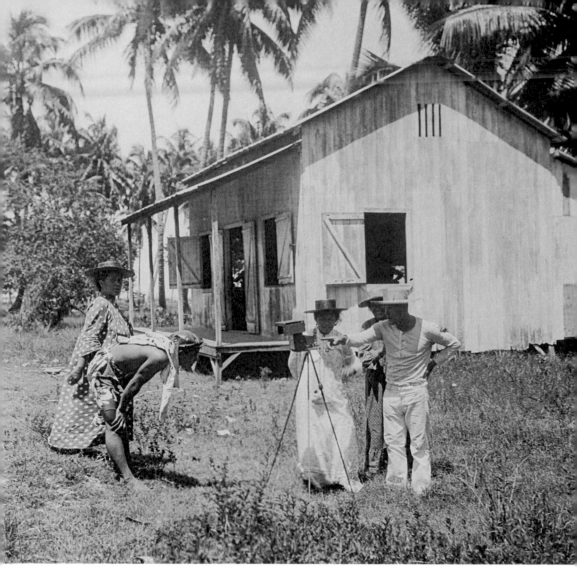

Marquesans inspecting Jack London's camera. Nuku Hiva, 1907

the Marquesas. Occasionally we rode under wild limes and oranges—great trees which had survived the wilderness longer than the motes of humans who had cultivated them. […]

Chapter X – *Typee*

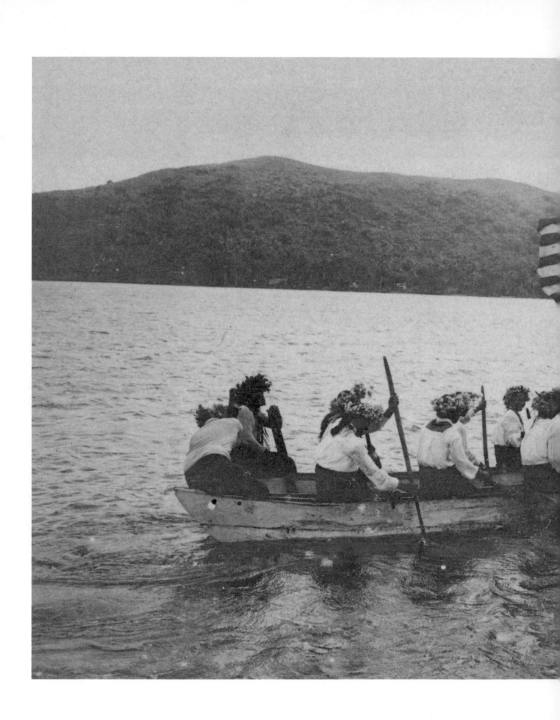

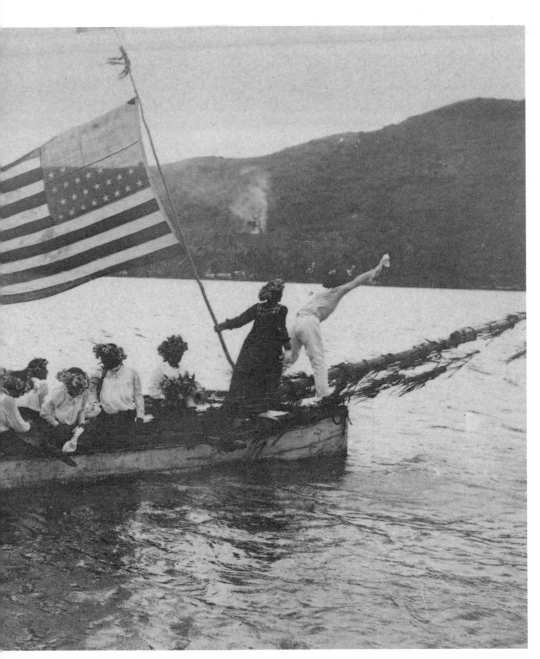

Bora Bora, 1908

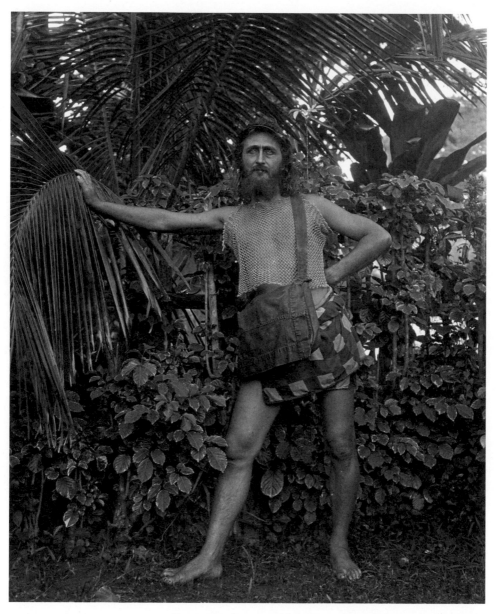

Ernest Darling, called "Nature Man". Papeete, Tahiti, 1907

[...] One sunny morning, the *Snark* poked her nose into a narrow opening in a reef that smoked with the crashing impact of the trade-wind swell, and beat slowly up Papeete harbour. Coming off to us was a boat, flying a yellow flag. We knew it contained the port doctor. But quite a distance off, in its wake, was a tiny out rigger canoe that puzzled us. It was flying a red flag. I studied it through the glasses, fearing that it marked some hidden danger to navigation, some recent wreck or some buoy or beacon that had been swept away. Then the doctor came on board. After he had examined the state of our health and been assured that we had no live rats hidden away in the *Snark*, I asked him the meaning of the red flag. "Oh, that is Darling," was the answer.

And then Darling, Ernest Darling flying the red flag that is indicative of the brotherhood of man, hailed us. "Hello, Jack!" he called. "Hello, Charmian!" He paddled swiftly nearer, and I saw that he was the tawny prophet of the Piedmont hills. He came over the side, a sun-god clad in a scarlet loin-cloth, with presents of Arcady and greeting in both his hands—a bottle of golden honey and a leaf-basket filled *with* great golden mangoes, golden bananas specked with freckles of deeper gold, golden pine-apples and golden limes, and juicy oranges minted from the same precious ore of sun and soil. And in this fashion under the southern sky, I met once more Darling, the Nature Man.

Tahiti is one of the most beautiful spots in the world, inhabited by thieves and robbers and liars, also by several honest and truthful men and women. Wherefore, because of the blight cast upon Tahiti's wonderful beauty by the spidery

human vermin that infest it, I am minded to write, not of Tahiti, but of the Nature Man. He, at least, is refreshing and wholesome. The spirit that emanates from him is so gentle and sweet that it would harm nothing, hurt nobody's feelings save the feelings of a predatory and plutocratic capitalist.

"What does this red flag mean?" I asked.

"Socialism, of course."

"Yes, yes, I know that," I went on; "but what does it mean in your hands?"

"Why, that I've found my message."

"And that you are delivering it to Tahiti?" I demanded incredulously.

"Sure," he answered simply; and later on I found that he was, too.

<div align="right">Chapter XI – <i>The Nature Man</i></div>

Yams, Solomon Islands, 1908

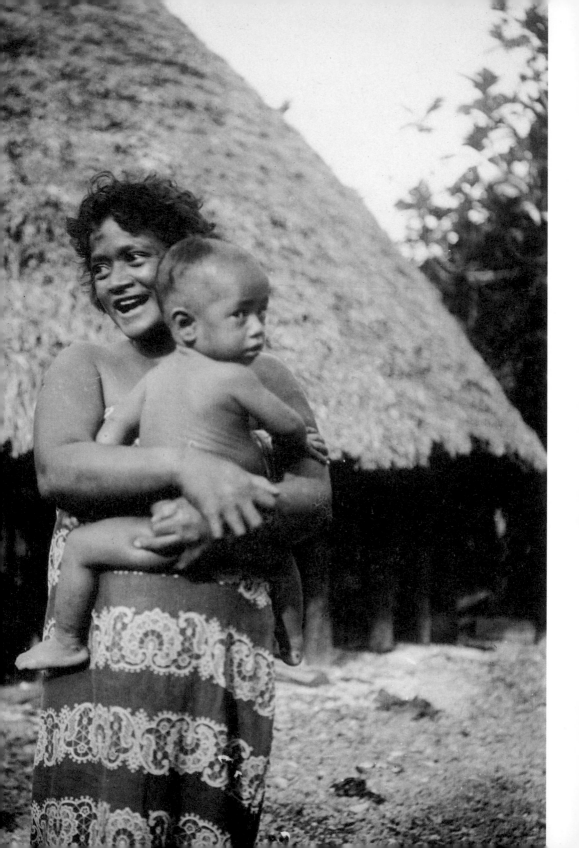

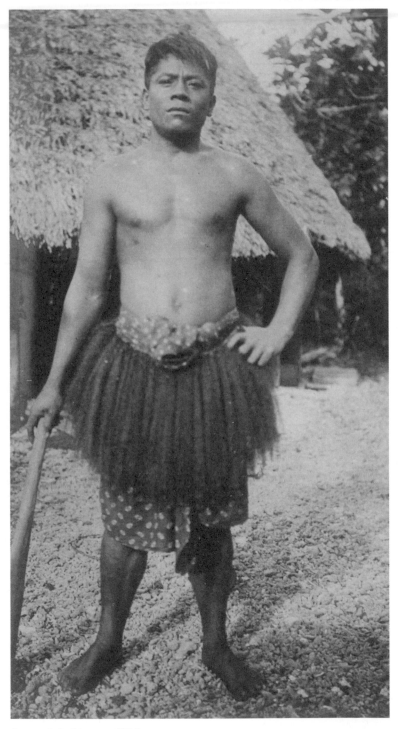

Samoa inhabitants, 1908

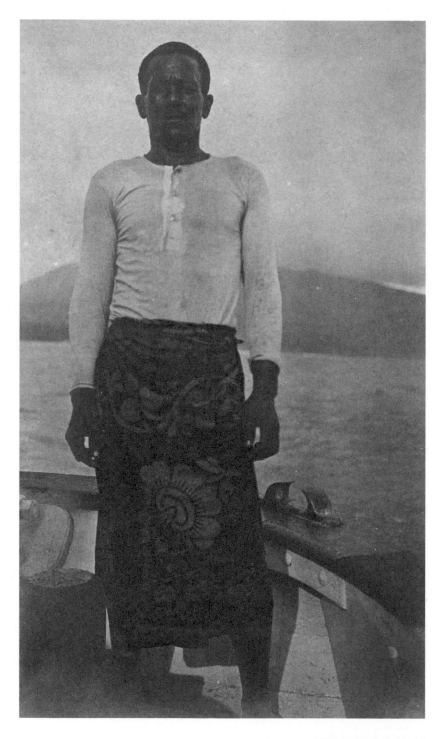

Tehei of Tahaa, 1908

[…] Close to the beach, amid cocoanut palms and banana trees, erected on stilts, built of bamboo, with a grass-thatched roof, was Tehei's house. And out of the house came Tehei's vahine, a slender mite of a woman, kindly eyed and Mongolian of feature—when she was not North American Indian. "Bihaura," Tehei called her, but he did not pronounce it according to English notions of spelling. Spelled "Bihaura," it sounded like Bee-ah-oo-rah, with every syllable sharply emphasized.

She took Charmian by the hand and led her into the house, leaving Tehei and me to follow. Here, by sign-language unmistakable, we were informed that all they possessed was ours. No hidalgo was ever more generous in the expression of giving, while I am sure that few hidalgos were ever as generous in the actual practice. We quickly discovered that we dare not admire their possessions, for whenever we did admire a particular object it was immediately presented to us. […]

Chapter XII – *The High Seat of Abundance*

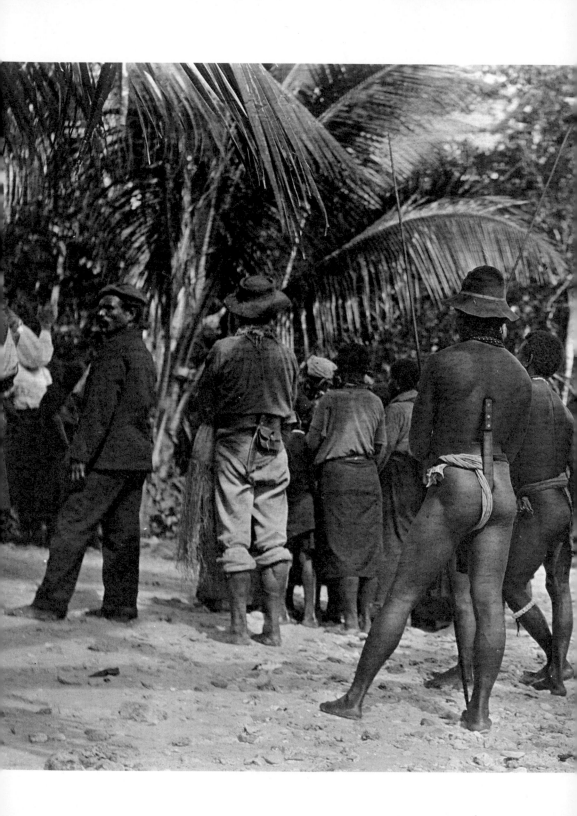

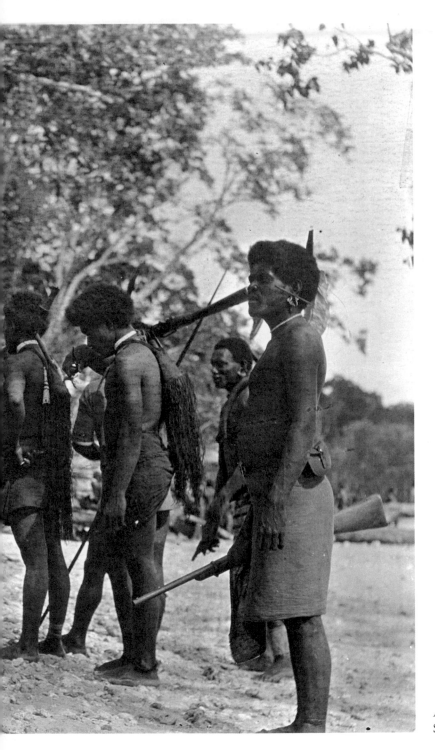

At the women's market.
Solomon Islands, 1908

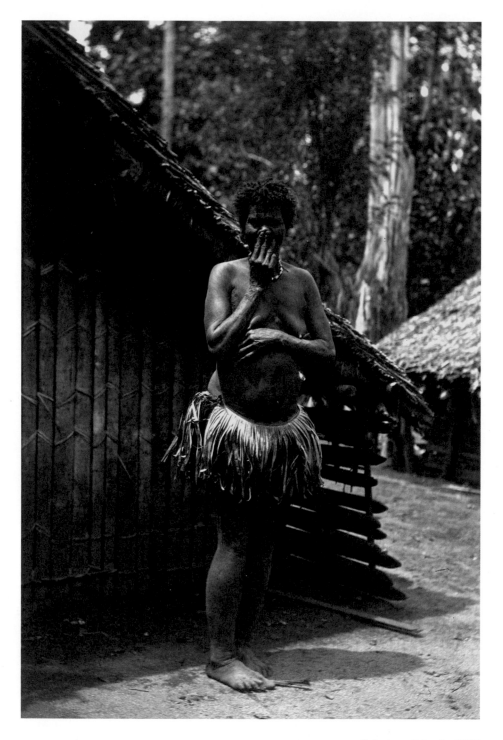

Solomon Islands, 1908

[...] No, the Solomon Islands are not as healthy as they might be. I am writing this article on the island of Ysabel, where we have taken the *Snark* to careen and clean her cooper. I got over my last attack of fever this morning, and I have had only one free day between attacks. Charmian's are two weeks apart. Wada is a wreck from fever. Last night he showed all the symptoms of coming down with pneumonia. Henry, a strapping giant of a Tahitian, just up from his last dose of fever, is dragging around the deck like a last year's crab-apple. Both he and Tchei have accumulated a praiseworthy display of Solomon sores. Also, they have caught a new form of gari-gari, a sort of vegetable poisoning like poison oak or poison ivy. But they are not unique in this. A number of days ago Charmian, Martin, and I went pigeon-shooting on a small island, and we have had a foretaste of eternal torment ever since. Also, on that small island, Martin cut the soles of his feet to ribbons on the coral whilst chasing a shark— at least, so he says, but from the glimpse I caught of him I thought it was the other way about. The coral-cuts have all become Solomon sores. Before my last fever I knocked the skin off my knuckles while heaving on a line, and I now have three fresh sores. And poor Nakata! For three weeks he has been unable to sit down. He sat down yesterday for the first time, and managed to stay down for fifteen minutes. He says cheerfully that he expects to be cured of his gari-gari in another month. Furthermore, his gari-gari, from too enthusiastic scratch-scratching, has furnished footholds for countless Solomon sores. Still furthermore, he has just come down with his seventh attack of fever. If I were king, the worst punishment I could inflict on my enemies would be to banish them to the Solomons. On second thought, king or no king, I don't think I'd have the heart to do it. [...]

Chapter XV – *Cruising in the Solomoms*

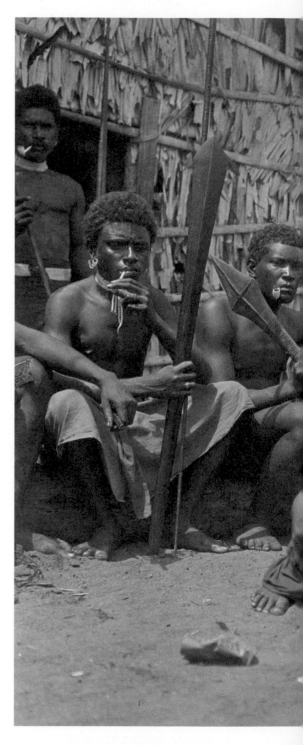

A family in front of their home, showing their
prized possessions, including tobacco leaves.
New Hebrides, 1908

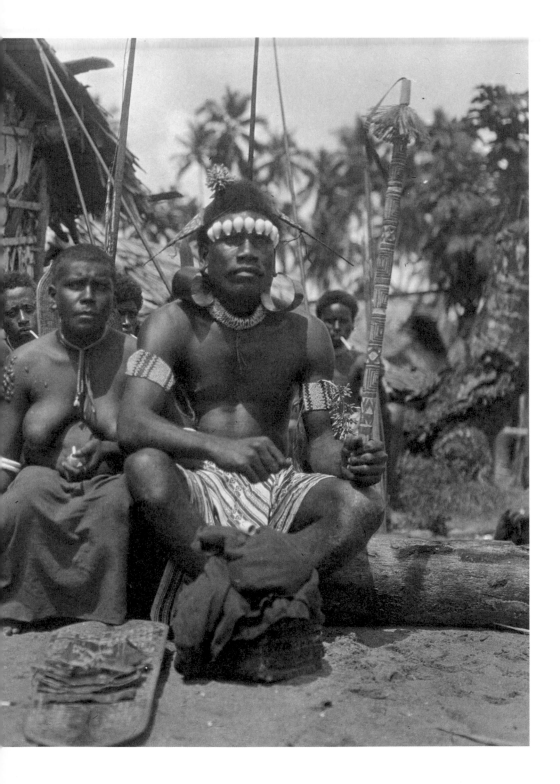

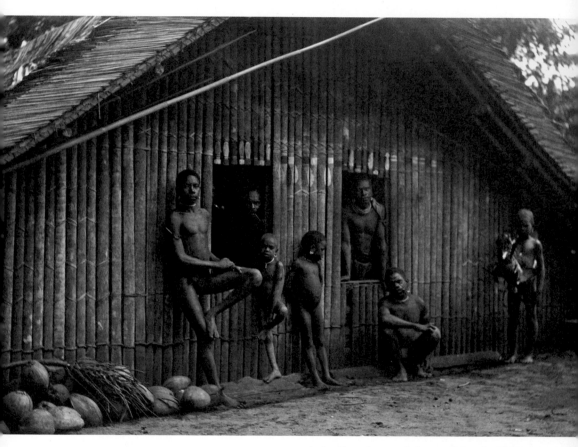

A family at home, Salomon Islands, 1908

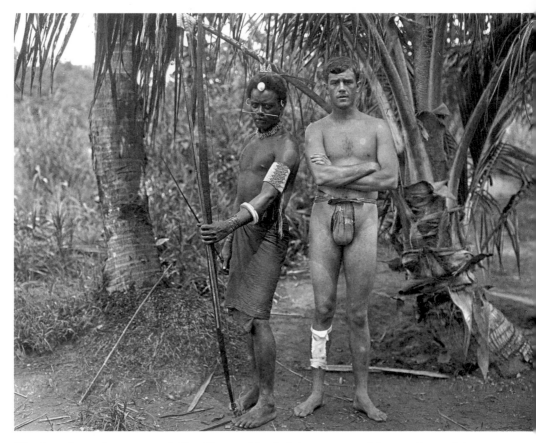

The American adventurer and film director Martin Johnson, one of the members of the Snark crew, poses with a native of the Salomon Islands. Guadalcanal, 1908

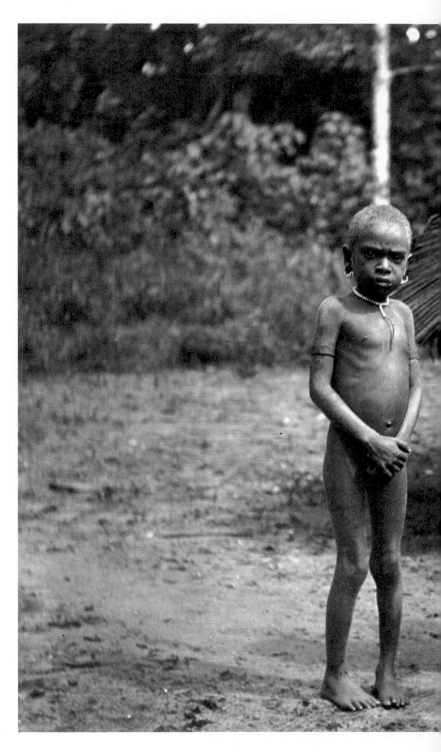

Salomon Islands, 1908

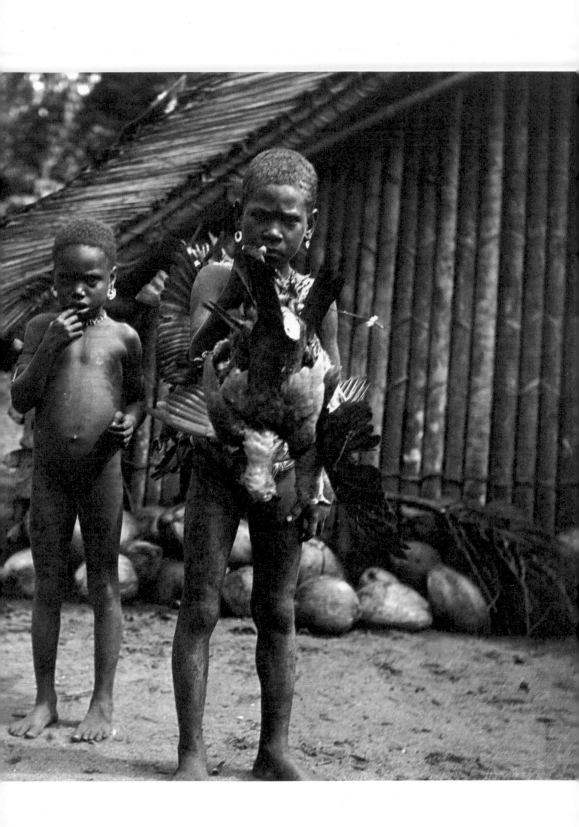

Jack London at the Beauty Ranch. Glen Ellen, USA, 1916

Biography

Jack London was born on 12 January 1896 in San Francisco, California, the son of William Henry Chaney, a wandering astrologer, and the spiritualist Flora Wellman, who was abandoned immediately after she became pregnant. Later that year, Flora married John Griffith London, who gave the boy his own name. In 1886, the Londons moved to Oakland. Jack's mother ran a boarding house, while Jack worked as a newsboy, frequenting the local public library and developing a love of literature.

With his first savings, he acquired a small boat, the *Razzle-Dazzle*, in which he carried out several raids in San Francisco Bay, becoming a skilled "oyster pirate" and, shortly afterwards, he enrolled as a coastguard with the task of preventing the smuggling of fish. In 1893, he embarked on the *Sophia Sutherland*, setting off on a voyage that was to take him as far as Japan and the Bering Sea, subsequently using his experiences to write *Story of a Typhoon Off the Coast*. In 1894, he joined Kelly's Army, a veritable army of the unemployed which was marching towards Washington. After a while, Jack abandoned the march and began to travel round the country. He was arrested for vagrancy and spent thirty days in jail. He explored the East Coast and Canada on board railway carriages transporting coal, recounting his experiences in *The Road* (1907). In 1895, he returned to Oakland, where he met Mabel Applegarth, who later provided the inspiration for Ruth Morse in *Martin Eden*. It was Mabel who encouraged him to enrol at the University of Berkeley. After passing the admission exams, Jack attended the university for one semester only due to continuous financial problems.

He continued to write, found work in a laundry and began to study socialist theory: he read Marx, Saint Simon and Proudhon. He joined the Socialist Party and embarked on the task of spreading socialism, which also led to him standing as a candidate to become mayor of Oakland on two occasions, in 1901 and in 1905, but without success.

On 25 July 1897, he boarded the *City of Topeka*, sailing to Alaska, then in the grips of the Gold Rush. Jack spent an entire winter in a cabin in the Yukon, but caught scurvy and was forced to return to Oakland. This experience inspired him to write "To Build a Fire" (1902). Returning home, he was determined to become a professional writer. In 1899, he sold his first story "To the Man on the Trail" to the *Overland Monthly* and the following year published his first collection of stories: *The Son of the Wolf: Tales of the Far North*. On 7 April 1901, he married Bessie Maddern, who had taught him at university. The couple had two daughters, Joan and Bess. In 1901, the short story collection *The God of His Fathers and Other Stories* was published. In August and September of 1902, he spent several weeks in the slums of London's East End, gathering material for his book *The People of the Abyss*, published in 1903. In the same year, he would also publish *The Call of the Wild*, which became a best seller, followed a year later by *The Sea-Wolf*.

From January to June 1904, he was in Korea and Manchuria, working as a correspondent covering the Russo-Japanese War for the *San Francisco Examiner*. Returning to America, he moved to Glen Ellen, in Sonoma County, where he acquired the first fifty hectares of what was to become his Beauty Ranch. Meanwhile, on 18 November 1905, he obtained his divorce from Bessie and the following day married Charmian Kittredge. That year, he published *The Game* and the short story collection *The War of the Classes*. In 1906, *White Fang* and the theatrical work *Scorn of Women* appeared.

On 23 April 1907, he sailed from Oakland on board the *Snark*, on a voyage that was to take him across the South Seas to Sydney, Australia, where the voyage was interrupted due to a rare tropical disease forcing Jack to seek hospital treatment. In 1908, he published the novel *The Iron-Heel*, and the following year, *Martin Eden*, to great public acclaim. These were followed by the collection of essays *Revolution*, short story collection *Lost Pace* and the travel journal *The Cruise of the Snark*. Meanwhile, in 1911, work began on the construction of Wolf House, a substantial building in sequoia wood and stone. He published the Hawaiian story collections *The House of Pride and Other Tales of Hawaii*, and two short stories *A Son of the Sun* and *Smoke Bellew*.

On the night of 22 August 1913, just as work was nearing completion, the house of his dreams was reduced to ashes by a fire. The disaster, together with financial difficulties, had a profound effect on London, and a deep depression caused his health to deteriorate. Between 1915 and 1916, Charmian persuaded him to spend a few months in Hawaii, where his condition seemed to improve. In 1913, tackling the theme of alcoholism which affected him personally, he published the novel *John Barleycorn*, while early in 1915, *The Star Rover* appeared. In September, his health dramatically deteriorated. On 22 November 1916, Jack London died at Glen Ellen at the age of 40, due to uremia. His death was provoked by a strong dose of morphine taken to combat extremely painful renal colic. For a long time, it was dismissively considered to be suicide and only recently has been acknowledged as accidental.